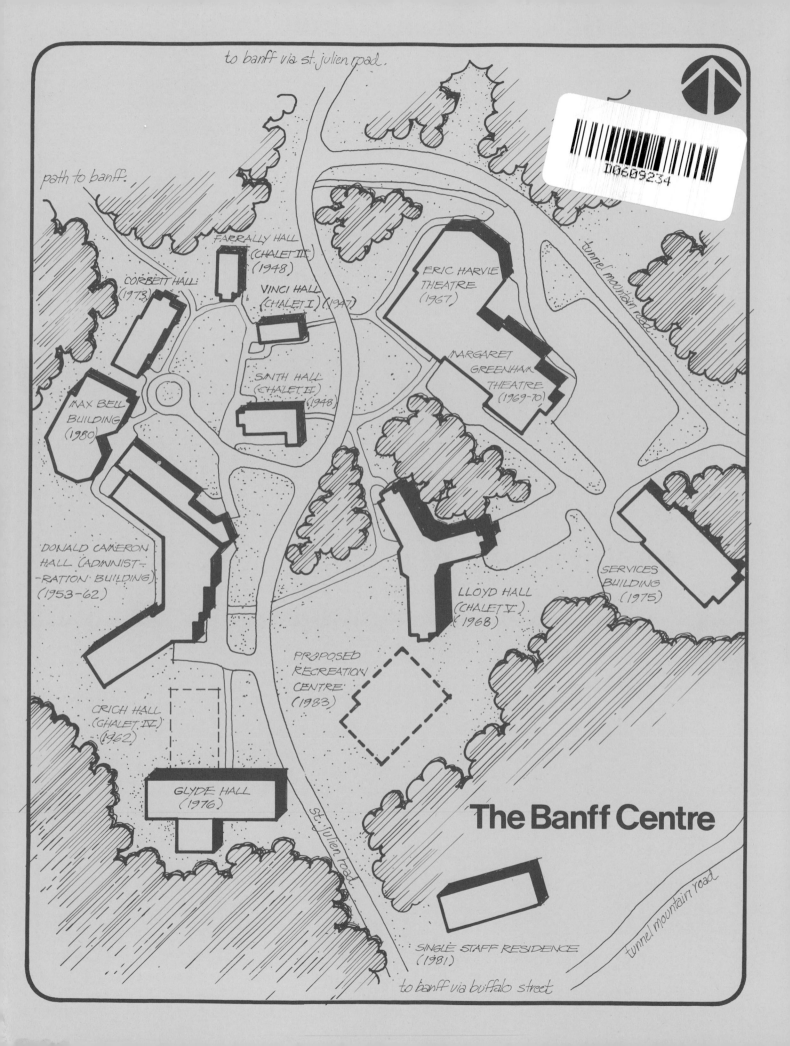

to banff via st. julien road.

path to banff.

FARRALLY HALL
(CHALET III)
(1948)

CORBETT HALL
(1973)

VINCI HALL
(CHALET I) (1947)

ERIC HARVIE
THEATRE
(1967)

MARGARET
GREENHAM
THEATRE
(1969-70)

SMITH HALL
(CHALET II)
(1948)

MAX BELL
BUILDING
(1980)

DONALD CAMERON
HALL (ADMINIST-
-RATION BUILDING)
(1953-62)

LLOYD HALL
(CHALET V)
(1968)

SERVICES
BUILDING
(1975)

PROPOSED
RECREATION
CENTRE
(1983)

CRICH HALL
(CHALET IV)
(1962)

GLYDE HALL
(1976)

St. julien road

The Banff Centre

tunnel mountain road

SINGLE STAFF RESIDENCE
(1981)

to banff via buffalo street

tunnel mountain road

Artists, Builders and Dreamers

Artists, Builders and Dreamers

50 YEARS AT THE BANFF SCHOOL

David Leighton

Research and Photograph Selection
by Peggy Leighton

The Banff Centre
1933-1983

McClelland and Stewart

Every reasonable effort has been made to ascertain
the ownership of photographs used. Information
would be welcomed that would enable the publisher
to rectify any error.

The Canadian Publishers
McClelland and Stewart Limited
25 Hollinger Road
Toronto M4B 3G2

CANADIAN CATALOGUING IN PUBLICATION DATA

Leighton, David S.R., 1928-
 Artists, builders and dreamers

ISBN 0-7710-5244-8

1. Banff Centre — Anniversaries, etc. 2. Banff
Centre — History. I. Leighton, Peggy. II. Title.

NX407.C3B36 707'.1071233 C82-095061-0

Design by Bob Young
Endpaper maps by Doug Leighton
Printed and bound in Canada

Contents

Preface

This is a highly subjective portrait of a most unusual institution, now known as the Banff Centre for Continuing Education. Its history belies the rather dull and stuffy name. It is an exciting story, vivid with conflicts, perils, and dramatic rescues. Above all, it is the story of people – of artists, builders, and dreamers.

In many ways, it is the history of an era, the development of Canada's west. It is certainly a vital part of the story of cultural development in this country, for without the Banff Centre our arts and culture would be vastly different from what they are today.

By definition, history is selective. It picks and chooses, and the selector – the historian – is a subjective participant in the process. In my own case, as a principal actor in the last quarter of the story, my involvement has unquestionably coloured both judgement and understanding.

Page Smith, the noted American historian, put it well when he said: "The historian must recognize that history is not a scientific enterprise, but a moral one. It is the study of human beings involved in an extraordinary drama, and its dramatic qualities are related to the moral values inherent in all life. History is in large part the story of the men and women who have suffered and sacrificed to create the world in which we live."

I wanted to write a human story of the Centre, not a narrative. I decided to focus on the people who made it, their personalities and their motives, rather than chronicling the events in its history. When I set out to write the story, I was confident that I knew it rather well. How wrong I was! As I talked, read and listened, a far more complex picture emerged, full of subtleties and contradictions. My principal regret is in not understanding some of this complexity earlier in my own involvement in the history.

The most difficult aspect has been the treatment of individuals. Not all have contributed equally, and not all are so treated. The emphasis given has reflected my best judgement as to the importance of their part in the story. That judgement can certainly be questioned. By the same token, individuals who may have played important parts in the past may have been overlooked or their contributions inadvertently slighted. I can only apologize in advance for such failings.

Such merits as this book may possess are due to the aid, encouragement, and willing help of many people. Some of them are characters in the book. Others, less obvious, have helped in a variety of ways. Among them, Jim Parker and Gertrude Russell of the University of Alberta Archives were particularly knowledgeable and willing on the many occasions we called on them for help. Ralph Clark gave generously both facts and insights from his own research on university extension in Alberta. Marilyn Potts made available her interviews with many past faculty and staff. Ted Hart, Ed Cavell, and the staff at the Archives of the Canadian Rockies in Banff opened their files for our use on several occasions, as did the staff in the President's office at the University of Calgary. Georgeen Klassen and Patricia Ainslie of the Glenbow-Alberta Institute provided information and photographs from their collection.

Many members of the Banff Centre family, past and present, provided us with photographs, calendars, playbills, and personal reminiscences. One of the true delights of this exercise was the discovery of lost or unknown treasures from the personal files of participants and the sense of excitement we shared on such occasions. Among the many who contributed were Ann Arnold, Dave and Kay Bebb, Don Becker, Rhona Bilsland, Mary Cameron, Helen Collinson, Eric Cormack, Sonia de Grandmaison,

Mrs. Gwillym Edwards, Laura Edwards, Bob Foley, John Gibbon, Dorothy Hawley, John Hayes, Walter and Gretta Kaasa, Suzanne Kennedy, Archie Key, Doug Lefroy, Barbara Leighton, Nancy Lord, Eleanor Luxton, Shelley MacAulay, Mrs. J.W.G. Macdonald, Ken Madsen, Lloyd Montour, Imo von Neudegg, Mary Paris, Leona Paterson, Gordon and Georgine Peacock, Frank Peers, Gladys Phillips, Mrs. George Porteous, Ruth Quinn, Eric Richer, Liz Richer, Gwen Pharis Ringwood, Dorothy Johnson Steiner, Ken Sturdy, Kathy Watt, Jim and Barbara Webb, Ben West, Carol Wilkie, Mr. and Mrs. Lars Willumsen, John and Nancy Woodworth, Mrs. C.C. Wright.

Preparation of the research materials and several drafts of the manuscript was supervised efficiently by Natasha van Bentum, who also kept track of our budget.

Typing was handled for the most part by Helen Fields, Elizabeth Kellogg, and Debbie Rosen with assistance from Kelly Potter, Debbie Davidson, Sharon Frere, Glenda Birney, and Lynn Landers.

Photographs in the book have come from many sources. Credit should go to: Ron Adlington, Kimmy Chan, Vic Crich, Ron Duke, Bruno Engler, Bill Gibbons, Al Girard, Byron Harmon, John Mahler, George Noble, Kathy Watt, the CPR, the NFB, Bickford Photography.

Principal editor, advisor, and conscience was my good friend Ruth Fraser. Her diplomatic and editorial skills were tested many times in the arduous process of telling the author when he was wrong and why. That our friendship survived is a tribute to her consummate professionalism and good nature.

My greatest debt is to my wife and partner, Peggy, without whom this book could never have been written. She somehow managed to cope with running a large family, acting as chatelaine and hostess for the Centre, interviewing present and past participants, sorting through files, developing lists, as well as collecting and organizing photographs, calendars, playbills, and the host of other memorabilia that now form the basis of an archives for the Banff Centre. She made my job of writing the story seem easy.

David S.R. Leighton
Banff, Alberta
July, 1982.

Introduction by Donald Harvie

Some one hundred years ago, the railways pushed west and penetrated our majestic Canadian Rockies. They brought people to settle the land, and they laid the foundations for our busy and diversified present economy. In the early years, the new settlers concentrated on establishing farms and businesses, but around 1911, the three seeds of our culture – music, art, and drama – were planted and began to flourish in a very special way in Banff. This book tells the story of the Banff Centre. It covers two generations of people and their remarkable cultural achievement in an often harsh and unforgiving frontier land.

For two generations my family has been involved with Banff. As a young lawyer my father, Eric Harvie, came west to Calgary on that railway. I remember happy vacation times at Banff when I was a child – and the long meetings my father held with Senator Cameron, the director of the fledgling Banff School of Fine Arts. Those meetings frequently interrupted our skiing weekends, and we children grew impatient and frustrated as we had far more important things in mind than "discussing the School." When we were in the mountains, schools were truly far from our young minds.

But as I grew up, and later when I chose to return to Calgary (with a Harvard MBA), those earlier associations flourished and grew into a close ten-year relationship with the Senator and Earle MacPhee in the formative years of the Banff School of Advanced Management. More recently, we have been involved in the Centre's third area of education – the School of the Environment. Thus my family has been part of this story as it developed, and we are indeed proud to see a world-recognized "centre of excellence" sitting in that beautiful valley of trees above Bow Falls.

It takes very special people to make good things happen. With ideas, dreams, and talent for selecting and motivating others, the "capital" to house and operate a school can usually be attracted. In a most refreshing way, David Leighton has brought to life the personalities of those who have built the Banff Centre. Everyone knows that the central player was Donald Cameron, with his vision of a Campus in the Clouds. Perhaps few realize the most critical dedication of the many others who also made their significant contributions both before and after his leadership years. It is timely to recognize them.

What is also important is the manner in which many of the early contributions were offered. I remember the 1952-1960 period and two extremely popular lecturers on the Canadian economic scene – Jack Firestone and John Deutsch. They came from Ottawa on alternate B.S.A.M. programs with only expenses paid, and each regularly took the time from his own annual vacation. Such commitment and dedication by many others is also shown clearly in the chapters about the School of Fine Arts.

In the summers, we have frequently paid visits to the Centre with travellers from afar. The special atmosphere and obvious enthusiasm were quickly evident in the friendly mingling of staff with students, the wholesome camaraderie at mealtimes, the late-evening continuation of classes as eager students found that learning can be both its own reward and good fun, especially when offered by the very best in the particular field. Students learn skills by perseverance, questions, and observations. Teachers impart their philosophies along with their skills. Often the corridors, the lawn, and the mountain trails become extensions of the classrooms. As time has passed, some of the alumni have returned to lecture or teach – and so the circle is completed.

As David Leighton completes this historical review, he also closes the door of his own direct involvement. We know that he, Peggy, and their family will not forget the Centre when he assumes

the next important challenge of his most varied career – he will be the President of the 1988 Winter Olympics to be held in and around the city of Calgary and the great mountains to the west. One might predict a rather special cultural flavour to be added to the expected athletic activities...and why not?

Of course, the true beneficiaries of the legacy of the Banff Centre are all of us: those of us who were trained or encouraged by spending time at the Centre; those of us who have enjoyed a play, listened to an orchestra, read a book, or learned to better manage people, businesses, or even cultural organizations. We may live in busy cities, in quiet towns, or in the peaceful country, yet the Banff Centre has most certainly touched upon all our lives, and will do so again and again in its next fifty years.

Donald Harvie
Calgary, Alberta

1

A Missionary Vision

They called him "Tiny," of course. Albert Edward Ottewell was a huge bear of a man – six foot three, and nearly three hundred pounds. Near-sighted, rough-hewn, and down-to-earth, he was a very unlikely missionary for University Extension. Yet a missionary he was, although not the kind he had envisioned when he and thirty others enrolled at the brand-new University of Alberta in 1908.

Ottewell wanted to be a Methodist minister. As a young man in 1890, he had come with his family from Ontario to a farm near Cloverbar, Alberta, and started working as a miner and farmer. At the age of twenty-seven, he caught the education bug, went back to school, and wrote his grade-eight examinations. In 1907, he entered Alberta College, a Methodist school in Edmonton, and when the University of Alberta was started in 1908, he transferred to the fledgling campus, fully intending to enter the service of the church upon graduation.

This big, friendly giant, considerably older than his student colleagues, was an instant star. He was active in student government, President of the Students' Union, a member of the Literary Society, a founding member of the student paper. When he graduated magna cum laude with the first class at the university in 1912, he was winner of the gold medal in Classics. He might have become a Methodist minister had it not been for his meeting with another visionary, Henry Marshall Tory, the founding President of the University of Alberta.

Tory had ambitions of his own for the university, and he liked the new graduate who had done so well under trying conditions. He asked Ottewell to become Secretary of the Department of Extension in the summer of 1912, and Ottewell could not resist.

Tory and Ottewell were a strange but effective pair. Tory was frock-coated and cultured, a former McGill University professor. He was a Methodist minister who had come to Alberta on a frosty day in January 1908 to set up the province's first university. "Tiny" Ottewell was a boisterous man of the soil who had allowed himself to be convinced that his missionary talents lay elsewhere than in spreading the gospel. Together, they were to lay the groundwork for the most imaginative and far-ranging educational-outreach program of its time.

Tory and Ottewell were intellectual soul-mates, completely of one mind on the importance of bringing education from the classroom to where people lived – their homes, church halls, and schools, in small and large communities alike. For Tory, it was both a practical necessity and a matter of philosophical conviction.

The province of Alberta was created in 1905, and the Liberal Party formed its first government under Premier A.C. Rutherford. A plank in their election platform was the establishment of a university and agricultural college, and true to their promise, the legislature passed the bill establishing the University of Alberta in the spring of 1906.

There were few who felt that the university commanded high priority. Most believed it was a fanciful and foolish waste of funds at a time when so many practical issues demanded attention in the frontier province. E.K. Broadus, first professor of English literature at the university, said that there were only two people who felt the founding of the university was appropriate at that time – Tory and Rutherford.

Moreover, Rutherford had announced in 1907 that the university would be located in Edmonton, in his home riding of Strathcona. Then, as today, the perennial Edmonton-Calgary rivalry was fierce. Most people assumed that since the capital was to be located in Edmonton, the university would be established in Calgary. A storm of public protest

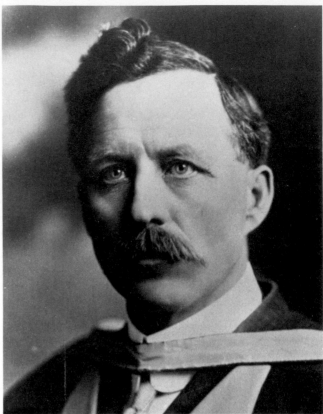

A.E. Ottewell as a student at the University of Alberta, 1910.

Henry Marshall Tory, first President of the University of Alberta.

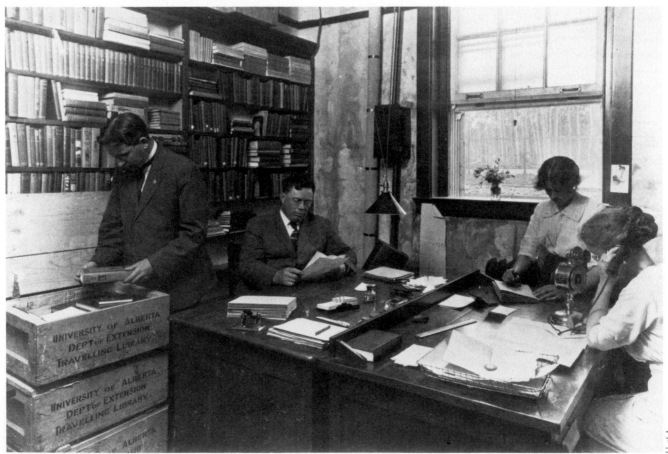

Extension Department Command Post, circa 1914. Ottewell (l.) and Librarian, Jessie Montgomery (r.), seated at desks.

greeted Tory when he arrived in Alberta in 1908. He had to sell the idea of the new university to the public and tax-payers of the whole province, and that meant reaching out to the people, not creating a remote, elitist institution that had no meaningful place in their lives.

In this case, necessity coincided with the philosophical sensibilities of the man. Tory was an egalitarian, an intellectual who had great faith in the common man. He believed passionately in the secular university at a time when most universities of the Maritimes and eastern Canada had religious affiliations. He believed that the University of Alberta should be firmly rooted in its prairie environment and he saw the urgent need to get on with the job of strengthening the university by means of its extension services. In an early address he said: "The university is supported by the taxes of the people; 75 per cent of them will never see it. The duty of the Department of Extension is to relate the research, the thinking, and the spirit of the institution to the problems of the people who pay for it." From the first year of the university's life, when there were only five faculty members, including Tory, a series of popular lectures was offered on topics ranging from Shakespeare and Tennyson to French conversation and sewage treatment.

When Ottewell graduated in early 1912, the groundwork had been laid for an Extension Department. A thousand dollars of the 1912 budget were earmarked for the hiring of an Extension Secretary – the first time a university had allocated a specific amount expressly for non-agricultural extension education in Canada.

Ottewell, the ex-miner, farmer, and would-be Methodist missionary, was appointed Extension Secretary. In 1913, at Tory's request, Ottewell travelled to the University of Wisconsin to study the extension work being done there. He was very impressed, and that program was to have a considerable influence on the work he would do in Alberta upon his return.

One of Ottewell's earliest acts was to introduce a travelling library service to supplement the extension lectures that had already been established. Then he started a publishing program, through which the department distributed literature on various subjects of current interest – women's suffrage, consolidated schools, immigration, the League of Nations.

In 1914, the department received about a thousand slides that dealt with issues related to Britain's entry into the First World War. These propaganda slides were intended to enlist support for the war effort, but Ottewell used them as accompaniments to the lecture series and instructed the department's faculty in the use of new, acetylene-powered "Magic Lantern" projectors. Ottewell himself went out on the road with a projector and showed slides, gave lectures, told jokes, and led sing-songs as part of an evening's entertainment that won great favour with audiences. E.A. (Ned) Corbett, later to succeed Ottewell, described the Extension Secretary at work in vivid terms:

> During the sixteen years in which he served as Director of the Department, he travelled continuously over dreadful roads, and no roads at all, in a Model-T Ford Coupe. The battered Ford car that he drove was tilted by his weight in the driver's seat at a downward angle of about forty degrees. From the rear it always seemed to be proceeding at a terrific speed with a crab-like motion. To pull his car out of the everlasting mudholes of the Alberta roads, he had an ingenious device by means of which he could fasten a rope to a distant tree or telephone pole, the other end wrapped around an enormous projecting rear wheel hub, thus he would force the groaning engine to do its own dirty work and I never could understand how the contraption managed to conquer a five-foot hole of gumbo, but it did.

Corbett referred to Ottewell as a "kind of educational Paul Bunyan." Everything about him – his voice, his laughter, his appetite, and his energy – was gargantuan.

He thought nothing of spending most of the night with a group of farm people, say at Pincher Creek in southern Alberta, and then starting at daylight after consuming a couple of cans of salmon, which was his favourite breakfast, to conduct a similar meeting at Coronation, about 300 miles away. This was in the days when there were few if any highways.

Ottewell was also a man of outspoken opinions. Once he made the sweeping statement that "if you wanted to find the most ignorant, inefficient man in the average Alberta community, you had only to look for the Chairman of the local School Board." In those years that remark had just enough truth in it to hurt, and Ottewell almost lost his job as a result. One of his most popular lectures was an illustrated dissertation on evolution. In Alberta's fundamentalist Bible Belt, public discussion of the subject required a great deal of courage.

In the winter of 1914-15, Ottewell obtained thirty stage plays suitable for amateur theatrical production. Within a month, all thirty had been distributed to communities in the province, where they were staged by farm groups in community centres and local schoolhouses. With a hard-working, often isolated people starved for cultural enrichment, the plays were immensely popular. Soon, Ottewell was banging on Tory's door for more funds to continue the program. It was this early demonstration of the public's need for artistic expression that led to the establishment, twenty years later, of a Theatre School in Banff.

It was wartime, of course, and towards the end of 1917, Tory and Ottewell left Alberta to travel to Great Britain where Tory had been appointed President of the Khaki College and Ottewell its Director of Extension. Khaki College was designed to assist servicemen in their re-entry into civilian life after the war. The two Alberta educators applied many of their radical ideas to teaching and counselling thousands of demobilized servicemen from the Allied Forces.

Ottewell returned to Edmonton in January 1918, and Tory a year later. They arrived back in the midst of a short-lived economic boom. The University of Alberta, for the first time in its young life, had received a substantial infusion of funds, and the budget of the Extension Department had been increased by four times its original amount of one thousand dollars.

With the enlarged funding, the two extension missionaries began another innovation, a major expansion of the audio-visual side of the department. The department hired its first visual-aids officer. His name was H.P. Brown, and he was also a Methodist minister. He took over the slide and film libraries and greatly expanded the whole use and application of the new communications technology that was emerging.

It was an exciting time. The new marvel of radio was revolutionizing communications. Brown became intrigued with the idea of radio broadcasting as a means of taking the university to the people. Arrangements were made with Edmonton station CJCA to carry lectures or talks on a variety of sub-

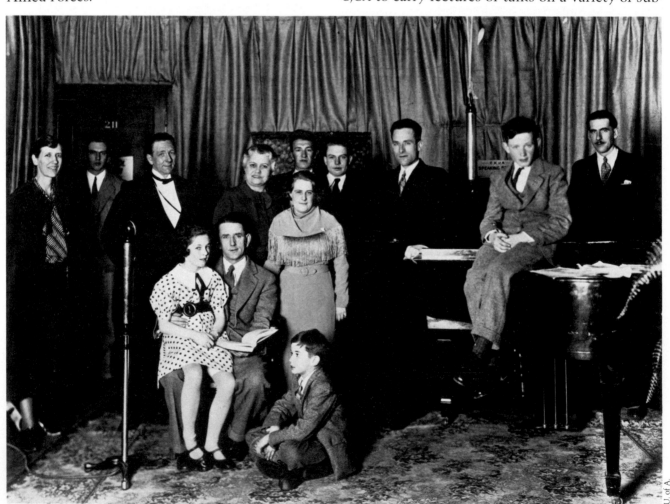

CKUA Players. Sheila Marryatt (l.) and Dick MacDonald (r.) were both to be involved in organizing the Banff School.

jects. The Canadian National Railway installed a radio receiver in the observation cars of its transcontinental trains so that passengers crossing the continent could pick up concerts and broadcasts from various stations en route. In 1932 the CNR developed a network of radio stations in Canada. This network later formed the nucleus of the CBC, although by that time, the University of Alberta had been broadcasting lectures and music programs for almost ten years.

Brown managed to manoeuvre things so that by 1927 the University of Alberta had its own radio station. It involved a certain amount of sleight-of-hand, because the university was, again, short of funds. The university's 1927 budget included a request for $7,000 for a new lecturer in the Department of Extension. The extra money was granted but the new lecturer never arrived. Mysteriously, a group of electrical-engineering students were busy at a course project, hand-building their own radio transmitter and antenna. When it was finished, the Department of Extension bought two old windmill towers and added some iron poles to form the basis

of their transmitter. These original transmitter towers, which stood until 1966, cost $2,000 of the $7,000 allocated for an extension lecturer. Meanwhile, a radio engineer helped design and build a studio and transmitter in what is now the university's power house. Although no formal licence had been granted, when presented with a *fait accompli*, the authorities decided it could go ahead, and on November 21, 1927, Radio Station CKUA made its debut.

At one stroke, the task of university extension – bringing the university to the people – had entered a whole new phase. As people in outlying communities bought radio receivers to while away the long winter nights, the university expanded its audience and, in effect, its student body. The university station went on to become one of the significant forces in the North American educational field. The station organized the CKUA radio orchestra, a twenty-member group of musicians who produced programs of opera, symphony, and concert music for broadcasts throughout the province. H.P. Brown himself was an announcer, ran sound effects, and

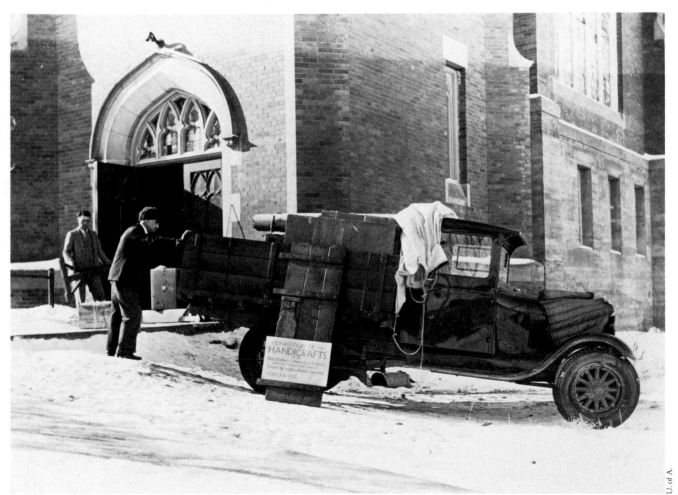

D.E. Cameron helping pack up an Extension Department handicraft exhibit.

directed studio programs. A large number of original plays was produced on this pioneer station. Sports activities were broadcast and foreign languages were taught on the air.

Thus it was that by the late 1920s, when the drought began in Alberta and the Depression threatened the assets of an entire generation, the University of Alberta could boast of a wide variety of sophisticated techniques for the promotion and delivery of adult education.

They were an unusual band, the pioneers of university education and extension in Alberta. Not entirely coincidentally, they all seemed to have had a strong dose of missionary zeal. To the original team of Tory and Ottewell had come people like H.P. Brown and, in 1920, D.E. Cameron, a Presbyterian minister who served as Assistant Director of the department for a little more than a year before he became university librarian. He remained a major influence on extension activities. The following year, in 1921, Ottewell hired Ned Corbett, a Presbyterian minister, as his assistant. Corbett succeeded Ottewell as Extension Secretary in 1929.

These men of vision sought to deliver the university to the people, and they succeeded far beyond their dreams. In the process, they had created a climate that was to make possible a school of fine arts nestled in the mountains of Alberta.

2
The Road to Damascus

The early thirties was not the most promising time to start a theatre school. Alberta was in the depths of the Great Depression, an economic collapse complicated by a devastating drought that extended all over western Canada and the United States. Number One Northern, the finest hard wheat in the world, was selling for nineteen cents a bushel at the local grain elevators. Hogs were selling at two and a half to three cents a pound, steers were fifteen to twenty dollars, eggs three to four cents a dozen. Crops could not be sold for the cost of harvesting them. It was a time of hopelessness and despair.

In Calgary, a high-school principal and evangelist named William Aberhart was using the new medium of radio to preach the gospel and to advocate a new political movement called Social Credit. In the prevailing mood of disillusionment, people began to flock to his cause.

In Edmonton, Ned Corbett had taken over the University of Alberta's Extension Department just as the Depression started. Assisted by a young agricultural graduate named Donald Cameron, he began to initiate some programs of his own.

Corbett was a lean Maritimer from Truro, Nova Scotia. He was a graduate of McGill University and Presbyterian Theological College. After his ordination, he worked in mission fields in western Canada. At Fort Saskatchewan, Alberta, in 1912, he met Anna Rae Dickson. They were married and moved to Montreal when he was offered a job as Secretary of Strathcona Hall at McGill University. In 1916, he enlisted in the Canadian Forces and was commandeered overseas by Henry Marshall Tory to help organize Khaki College.

Corbett later said, in the wry, self-deprecating manner that was his trademark, that he had always hoped to be a Christian, but some essential quality of saintliness had evaded him. He had "started on the road to Damascus, but fell among educators." However the road twisted, Ned Corbett was to become one of Canada's educational pioneers in the field of adult education; he would also be the father of the Banff School of Fine Arts.

It was in England, in 1917, that he first met the man who was to have a profound influence on his life. Corbett was organizing lectures for the troops, and the first presentation had been a disaster. He wrote, in his memoirs, about his meeting with "Tiny" Ottewell.

> For the second lecture, we were to have Professor A.E. Ottewell from the University of AlbertaI think he was the biggest man I had ever seen in uniform. His Sam Browne belt would have made a surcingle for a good-sized bronco. He announced that he would give an illustrated lecture on "Evolution" and I was terrified at the thought of what might happen to him The auditorium was filled to overflowing, but ... no one left the hall until the last word had been spoken. First he got the men singing such old familiar favourites as "The Old Gray Mare," "I'm a Little Prairie Flower," "Old MacDonald Had a Farm." Then, with earthy wit and spontaneous laughter at his own sallies, he held his audience spellbound for an hour. After that ... the Canadian army could never have too much of Ottewell.
>
> I couldn't know then that this was the man I was to work with later in Alberta for many years, and who gave me whatever I have in the way of a working philosophy of adult education.

After the war, Tory offered Corbett a job as Ottewell's assistant, and in 1920 the Corbetts moved west. Soon, Ned was working on Ottewell's Magic Lantern circuit. He was a natural, for he had that essential quality needed in a roving lecturer: a sense of humour. His was a wry and sardonic view

of the world, and his humour frequently was directed at himself. While Ottewell started every lecture with a song, Corbett opened with a joke, not a few of them risqué enough to shock his strait-laced rural audiences. He became one of Ottewell's most popular lecturers, and spent most of the next nine years on the road.

In the introduction to Corbett's book *We Have With Us Tonight*, Leonard Brockington, a close personal friend, wrote of Corbett:

> He is a wonderful raconteur and the best mimic whom I know. For he has an uncanny capacity for capturing accents and mannerisms and for summing up in a flash a situation and a character. He has a poet's eyes, but though they may not roll in a fine frenzy, they gleam with fun. He possesses everything that is included in that indefinable phrase – a sense of humour. For with him it means a sense of proportion, a smiling derision of pomposity. He has always wanted to give to life a lift of merriment and to see us awakened to happy laughter over ourselves.

In 1929, Ottewell became Registrar of the university, and Corbett succeeded him as Director of the Extension Department. One of his first priorities was the expansion of H.P. Brown's radio station. Although he had been sceptical about radio at first, Corbett was by now a genuine enthusiast and a leading advocate of public broadcasting in Canada.

Word spread of the innovative educational experiments in Alberta, and in 1931 the campus was visited by Dr. Learned of the Carnegie Foundation in New York. Learned suggested to the university's President, R.C. Wallace, that he apply to the foundation for help in developing an extension program in fine arts. Corbett wrote:

> Accordingly, with much prayer and fasting . . . plans were submitted The plan called for the appointment of a full-time instructor in dramatics, the provision of highly qualified adjudicators for the Alberta School Music Festivals, already well established throughout the province, and the circulation of art and handicraft exhibits to schools and adult organizations.
>
> The first of these, the appointment of a full-time instructor in dramatics, was perhaps the most important part of the plan and would absorb 50 per cent of the total budget. The reason for this was that the Depression had closed most of the small-town moving-picture houses and the people outside the larger cities were more and more

thrown back on their own resources for entertainment. The result was the growth of hundreds of small dramatic or little theatre groups. A great many of these, particularly in villages and rural communities, knew very little about choosing a play or how to stage it. Plays were often such inane and worthless scripts as "Deacon Stubbs of Perkins Corner," or similar drivel. It had been obvious for some time that if the Department of Extension was to give adequate direction to this movement a qualified director was needed, and we had already added to our staff Mrs. Elizabeth Sterling Haynes, a graduate of the University of Toronto, who had for some years played a distinguished role as an actress and producer in the Alberta Drama League.

In the spring of 1932, a grant of $10,000 a year for three years was approved by the Carnegie Corporation. Elizabeth Haynes was hired full-time, and Corbett and the Extension Committee turned their attention to the happy task of allocating the grant monies.

W.G. Hardy, a university faculty member, novelist, and sports enthusiast, recorded the disposition of the Carnegie funds on Amateur Hockey Association letterhead. He stated that one part of the program would be "supervision of and assistance in the production of plays by groups in centres in the province where such help is requested. It is thought, for instance, that if a centre such as Stettler wishes to produce a play that Mrs. Haynes will go out to such a centre and give assistance in the choice of play, in casting and in direction." Another activity would be a school of direction, to be held in May "after the feeling for drama has been developed in certain centres."

According to the extension report of 1933, Elizabeth Haynes "assisted twenty-eight groups in communities all over the province in choosing and producing plays, making several visits to each place." She also gave a series of lectures on amateur theatre. But there were nearly 300 small drama groups in Alberta, all needing help in various ways. As Corbett stated, "It became clear that a summer school in the theatre arts was greatly needed."

Thus it was in the spring of 1933, when the Alberta Drama Festival was being held in Lethbridge and Corbett was President of the Alberta Drama League, that Ned and Elizabeth went to Lethbridge to attend the Festival and the annual

E.A. Corbett, portrait by Irma Coucill.

Irma Cornill

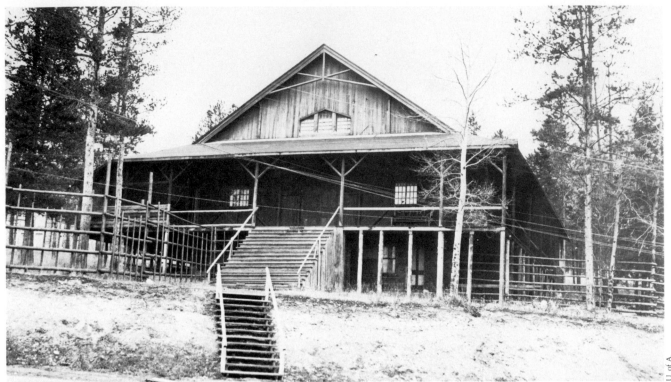

Bretton Hall, first home of Banff Summer School.

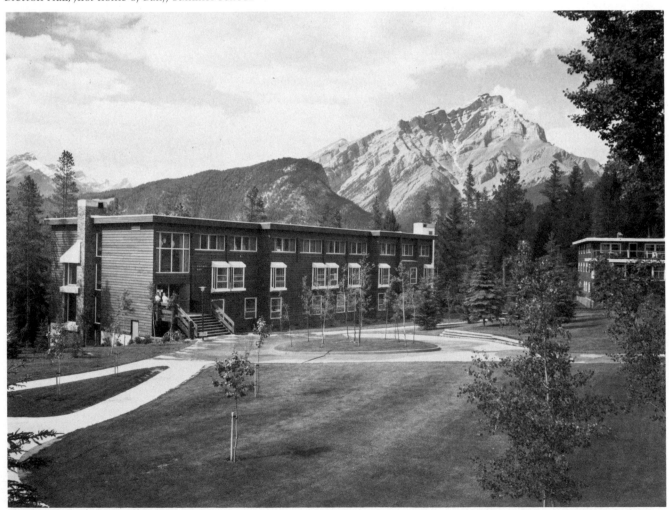

Corbett Hall on the Banff Centre campus.

*Ned Corbett (l.) with a young Roby Kidd (r.).
Two generations of adult education in
Canada.*

Extension Department Tea Party, circa
*1933. Donald Cameron and Ned Corbett
standing at back. Elizabeth Haynes seated
third from right, Gwen Pharis at right.*

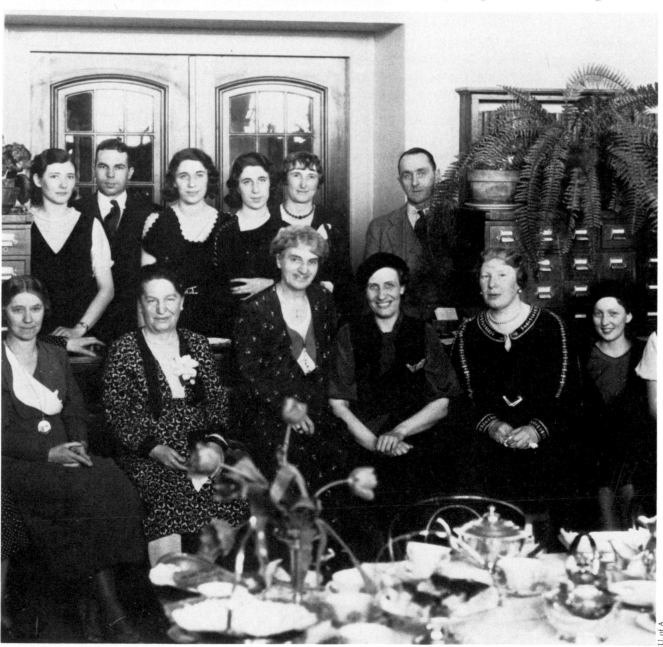

meeting of the League. They presented a proposal for a summer training School of the Theatre in Banff or Jasper and asked for the League's approval and support. The League's executive, however, felt the idea was premature and that the venture would probably fail. Support from the League was effectively denied. But Ned and Elizabeth would not let the idea perish, as Corbett describes in his memoirs:

> When we returned to the university I discussed the matter with the President, Dr. R.C. Wallace and the Extension Committee, which was composed of Dr. John McEachern, Dr. W.G. Hardy, myself, and the President. Dr. Wallace pointed out that the Institute of Pacific Relations was meeting at the Banff Springs Hotel that summer and there might be difficulty in getting sufficient accommodation, but if we could overcome physical problems of that sort he would give the plan his approval and authorize the use of $1,000 from the Carnegie grant to finance the undertaking.

Corbett promptly drove down to Banff and discussed the plan with the town's School Board, service clubs, and members of the Banff Advisory Council. He was not above bending the truth a bit in order to get what he wanted: "I told them that we had thought of going to Jasper. There was quite a lot of accommodation there. Well, they immediately said, 'Oh, no. This won't do at all, you have to come to Banff.' Of course Jasper wouldn't have done in any case because the road from Edmonton was awful. It was also more difficult to get at than Banff, and not as well known then. So Banff it was."

The Banff School Board agreed to allow Corbett the use of public-school and high-school classrooms, library, and meeting rooms, the only charge being for janitor service. The local Little Theatre, eager to have the school in Banff, agreed to let them use Bretton Hall, "a rather shaky old theatre just across the bridge and facing the Bow River." While very basic, it had the necessary stage and curtains.

Students could fend for themselves as far as sleeping and eating were concerned. With his basic facilities guaranteed, Corbett began to advertise his first annual "School of the Drama, Banff, August 7 to 25, Registration Fee $1.00, no Tuition Fees."

And so it was born. Corbett remained as Director of Extension at the university and Director of the Banff Summer School for the next three years.

When, in 1936, he moved to Toronto in what he thought would be a temporary assignment as the first Director of the Canadian Association for Adult Education, he wrote:

> My sixteen years in Alberta were the happiest and the most exciting years of my life. To begin with, I loved my work. I was constantly on the move, meeting new people and new problems. The fact that we had available within the university a wealth of information which could make life fuller and more satisfying for everyone, provided me with an outlet for my inherited missionary instincts The years between 1925 and 1929 were golden years in the Canadian west, and it was good to be in it and part of it.

His memoirs, *We Have With Us Tonight*, end with a quote from E.M. Forster's book, *Two Cheers for Democracy*. The passage eloquently captures Corbett's credo:

> "I believe in aristocracy – not an aristocracy of power, based upon rank and influence, but an aristocracy of the sensitive, the considerate and the plucky. Its members are found in all nations and classes and through all ages, and there is a secret understanding between them when they meet. They represent the true human tradition, the one permanent victory of our queer race over cruelty and chaos."

3

A Woman Ahead of Her Time

The first "Dean" of Corbett's unlikely enterprise in Banff was a striking woman, six feet tall, with red hair, a commanding presence, and a voice that no one ever forgot. Elizabeth Sterling was born in 1898 into a remarkable Canadian family. Her brother Wallace later became President of Stanford University and one of the most distinguished educators in North America. Elizabeth made a reputation as an actress, and attended the University of Toronto where she studied under the famed Roy Mitchell, Director of the Hart House Theatre. W.G. Hardy, then a junior lecturer at the University of Toronto, lived at the same Charles Street rooming house, and the two became lifelong friends. Hardy was as short and slight as Elizabeth was tall and strong: "We used to skate at the Little Vic rink, although it was never quite certain whether I was guiding Elizabeth around the corners, or if I were being towed."

She was a striking woman, not beautiful in the sense of being pretty. She was imposing, with an aura of command and authority about her. Her voice was rich and low and strong. The adjectives most people used when talking about her were "vital" and "warm." She had *presence*. She was totally and passionately committed to the theatre; it was her temple.

Elizabeth left Toronto to teach drama in New York State in the early twenties, but returned to Canada in 1923. She married a dentist, Dr. Nelson Haynes, and they had just moved to Edmonton when by chance she met her old skating partner, George Hardy, on a street corner one day in the summer of that year. He had become very active in the University Dramatic Society in Edmonton and, aware of Elizabeth's background in the theatre, persuaded her to direct a production of J.M. Barrie's *Dear Brutus* for that group. The production was a tremendous success and led to Elizabeth's increasing involvement in the theatre in Edmonton. In 1929, when the Edmonton Little Theatre was formed, Elizabeth was its first Director. For the next three years, she directed and produced a number of memorable plays, including Molnar's *Liliom* and Barrie's *Mary Rose*.

In 1932, Ned Corbett hired her as the first full-time Head of the Theatre Division of the university's Department of Extension. A young girl named Gwen Pharis was engaged as Elizabeth's secretary and assistant. Together, they tackled the job of building a tradition of excellent theatre in western Canada.

When the Summer Theatre School at Banff was opened the next year, Elizabeth and Gwen found they were not alone in their goals. The small mountain town had a flourishing little-theatre tradition itself, nurtured by a group of local women headed by Margaret Greenham, who ran her own private school, Mrs. Dean Robinson, Mrs. C.M. Walker, and Eleanor Luxton. Their co-operation in providing the Bretton Hall Theatre, and their support, especially during that first year, were important to the success of the program.

Elizabeth engaged as her collaborators a handsome young Edmonton lawyer named Theodore Cohen, who had already distinguished himself as a technical producer, and his brother Eliot, who had experience in stagecraft and technical theatre. Courses were to be given in staging, costuming, play production, voice, and eurythmics. In preparation, Elizabeth put together in a huge mimeographed edition, a collection of twelve one-act plays to be made available to students at a price of three dollars.

On opening day, the new school was flooded with students. Hoping for perhaps forty-five registrants, Elizabeth and her colleagues were surprised when nearly 190 enrolled, including a few from eastern

Elizabeth Sterling Haynes, first "Dean" of the Banff School.

Canada, the United States, and Australia. Many were rural school teachers, and there was a preponderance of women.

Ned Corbett recalled the presence of a farm couple from Saskatchewan at that first school.

> The man was about sixty years of age, his wife perhaps fifty. They had driven 500 miles from their farm, near the little town of Marshall, in a battered old Model-T Ford – the first holiday they had had in thirty years. They had a tent, burning and cooking equipment, and they set up their establishment somewhere on the side of Tunnel Mountain. At first no one noticed them. Then one day, after one of the lectures, they came forward and offered their services. The man was a skilful carpenter and was at once put to work making stage sets, and his wife to helping with costumes. They were a quiet, dignified and extraordinarily handsome couple, and were soon popular with students and staff.
>
> One day about a week after the school opened, they handed Mrs. Haynes a one-act play that they had written. They were very hesitant about it, afraid it wasn't much good, but would she read and criticize it for them? I think it was called *Defeat*, and it depicted life on a Saskatchewan wheat farm during the Depression. Mrs. Haynes and Ted Cohen were so enthusiastic about its possibilities that they decided to produce it on

the closing night, when a number of plays written by students were to be presented. The man and his wife were cast as the father and mother, and I think the only other members of the cast were a son and daughter, picked from the student body. It was such a success that it was later entered in the Saskatchewan Drama Festival and was chosen to represent that province in the Dominion Drama Festival in Ottawa in the spring of 1934.

There, the authors won a prize for one of the best Canadian plays, and very high praise for their acting.

On two occasions during those three weeks in the summer of 1933, the Drama School prepared and performed a program of three one-act plays before the delegates to the Institute of Pacific Relations, which was meeting at the Banff Springs Hotel during the month. The audience on these occasions included the Prime Minister of New Zealand and Henry Luce, whose magazine, *Time*, was emerging as one of the influential periodicals of the day. One of these plays, *The Slave with Two Faces*, was a great hit, and warmly commended by "a large and distinguished audience."

The school's quite unexpected success encouraged the university to try again the next year with an expanded staff, including Elizabeth's legendary mentor, Roy Mitchell, who by then had moved to New York University and was the author of one of the most widely read texts on the theatre. Gwen Pharis (later Ringwood), who was the school's secretary at the time, remembers Roy Mitchell. "He was a big man and he'd stroll around Banff with his pretty wife, Jocelyn, and Wallace House." House was a colleague from New York, and he and Jocelyn Taylor Mitchell gave some memorable classes on folk-singing. Mary Ferguson of Winnipeg, a graduate of Manitoba and McGill and a former instructor in eurythmics at Wellesley College, led sessions on pantomimic movement.

The production program was even more ambitious in the second year, and the classes mounted such plays as Maxwell Anderson's *Mary of Scotland* and Dunsany's *Gods of the Mountain*. These productions played to packed houses in the Bretton Hall Theatre. Enrolment that year was 151 adults and 32 children.

Banff School Faculty, 1937
Standing (l. to r.): Bernard Middleton, Viggo Kihl, H.G. Glyde, Leo Pearson, Joseph Smith. Seated (l. to r.): Arthur Adams, Grace Tinning, Gwen Pharis, E. Maldwyn Jones, Donald Cameron, Frederick Koch, Theodore Cohen, Elizabeth Sterling Haynes, Mrs. J.L. McPherson, Sheila Marryatt.

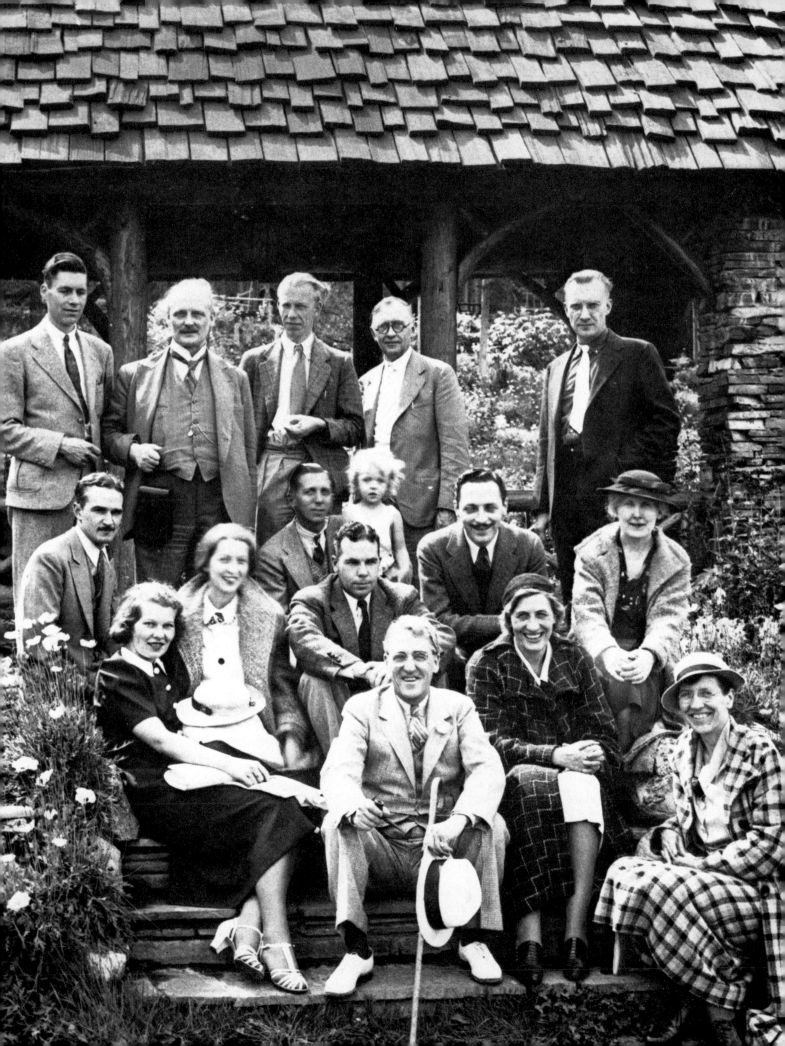

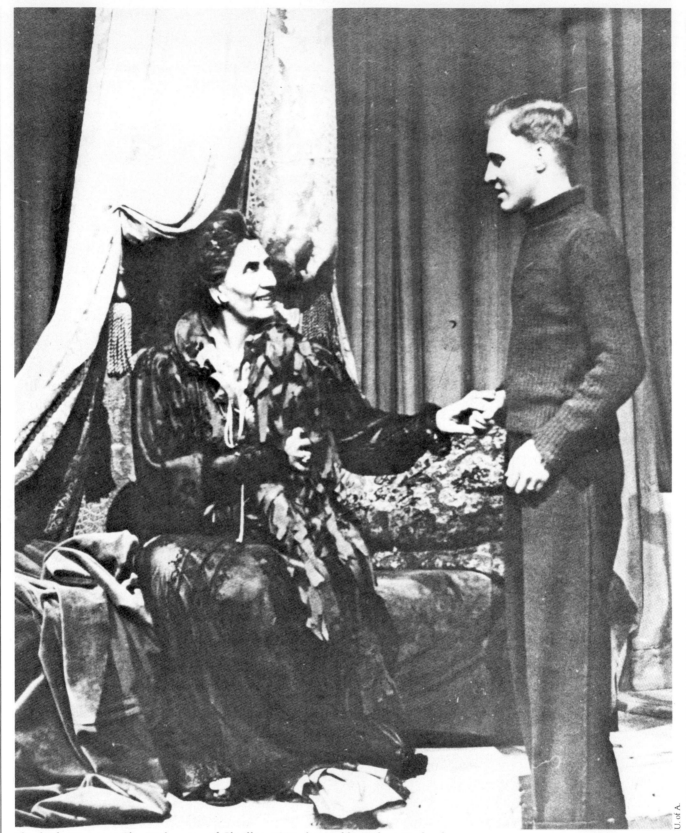

Elizabeth Haynes as The Madwoman of Chaillot, *1951, directed by Robert Orchard.*

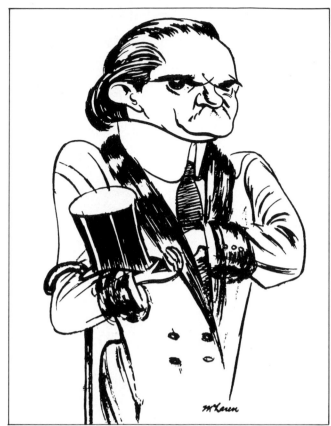
Caricature of Roy Mitchell, by Jack McLaren.

Elizabeth remained in charge of the Banff program until 1936, when the Carnegie grant finally gave out, after one extension. Dropped from her job in Alberta, she was offered a similar post in New Brunswick. She headed east to do it all over again. There, in the winter of 1937, she first encountered a young drama teacher named Evangeline (Van) Machlin, who was later to become an authority on speech in the theatre, and a professor at Boston University and a teacher at Banff. Van Machlin recalls that meeting:

> I remember vividly the first time I saw her. It was at the railway station in Sackville, New Brunswick, mid-winter in 1937. There stepped off the train this tall, loose-limbed woman, red-haired, with brilliant hazel eyes, big features (wonderful for the stage! she used to say of them), and a marvellous smile. Up we all went to the college, and that evening was spent in wonderful talk about theatre and the arts. The next week she spent with faculty and students, teaching theatre Elizabeth taught me more about directing in that short week than I would have believed possible . . . she told us all about Banff and the school starting there, how she had had the idea of using the church and schools, there

being nowhere else to work. She brought in people, students and community leaders to a summer of practical work in the theatre. I never forgot her descriptions: years later, when I was a trained and practising teacher of theatre speech, I remembered it and boldly applied for a job [in Banff].

Elizabeth eventually returned to Alberta and in 1949 she began teaching part-time at the newly created Drama Division of the University of Alberta. For six years she taught, acted, and directed in the old Quonset huts that were the Studio Theatre. In 1951, she performed the lead in the *Madwoman of Chaillot* for the Studio Theatre Players, a performance described by those who saw it as the high point of her work as an actress. The same year, she inspired a young student at the university named Thomas Peacocke to devote his life to the theatre; as actor, teacher, administrator, and director he became a major influence on the theatrical community in this country. Many others fell under her spell: people like Gwen Pharis Ringwood and Elsie Park Gowan, both prolific playwrights; Joe Shoctor, creator of Edmonton's famed Citadel Theatre; Betty Mitchell, who developed theatre in Calgary; Emrys Jones, who did the same in Saskatoon; and Mary Ellen Burgess, in Regina.

Gwen Pharis Ringwood wrote, in a tribute to Mrs. Haynes: "Elizabeth was a force; a creative energy unleashed at a time when creativity was suspect, and at a place where creativity was often ignored in the hope that it would go away To serve the theatre she risked health, security, personal conflict, peace of mind, disillusionment. At no time did she lose sight of what the theatre at its best has meant and can mean to humanity."

Her contribution to the Banff Theatre School was immeasurable. Had it not been for her talent and her ability to inspire others, the venture might easily have collapsed in those first years. As it was, she established the high standards and provided the energetic leadership that captured the imagination of those who were to follow. It was Elizabeth Haynes who built the base upon which the future Banff School was to grow.

She once expressed her philosophy of theatre art, a philosophy that could be applied to all art forms: "Dramatic art is an art which expresses and reveals all of life . . . it is a great art only insofar as it succeeds in identifying the individual with humanity . . . it should clothe an immeasurable amount of truth and a great amount of beauty."

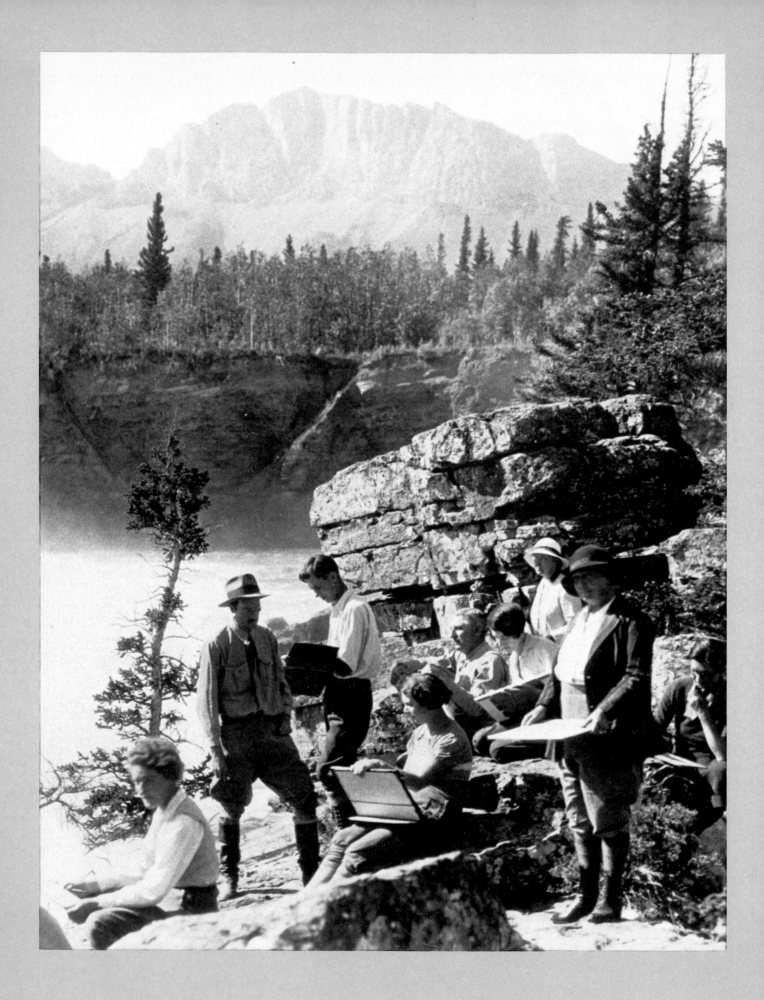

4

Cowboy with a Palette

While Ned Corbett and Elizabeth Haynes were creating their Drama School in Banff, down the Bow River at a dude ranch a reserved, meticulous Englishman was instructing a group of budding Calgary painters in the art of painting from nature. The painters were learning from a master.

Alfred Crocker Leighton – Ace to everyone – was born in the historic town of Hastings, Sussex, in 1901. He lied about his age to join the Royal Air Force in 1917. After the war, he worked for a brief time as a toy designer, then returned to art school, and taught for a year before heading out on his own to work as a free-lance artist.

In 1924, Ace and a colleague prepared a large-scale model of the Mersey docks. His model came to the attention of officials of the Canadian Pacific Railway, who invited him to do a number of similar models for the CPR. Still operating from his English studio, he visited Canada in 1925 and 1927, and soon became chief commercial artist for the railway. Most of the CPR brochures, menus, and posters used between 1926 and 1929 were designed by Leighton. His paintings of trains, ships, hotels, and mountains became classics and helped lure thousands of tourists to western Canada's virgin landscape.

In 1927, this "pink-cheeked, bespectacled youth" held his first Canadian exhibition, a collection of paintings of Kent and Sussex windmills, incongruously mixed with Rocky Mountain scenes. His show, which visited Vancouver, Banff, Calgary, and Winnipeg, received glowing reviews, including one favourable notice in the Winnipeg *Tribune* by another British artist, Walter J. Phillips. The two were later to become close friends and together

Sketching class at Seebe, 1932. A.C. Leighton (with hat) standing centre.

would play an important part in the development of a major painting school in the heart of Canada's mountains.

The favourable publicity from his exhibition brought the young English painter to the attention of Dr. William G. Carpenter, director of the Institute of Technology and Art in Calgary.

Carpenter believed strongly in the interaction of the trades and culture, and he wanted to build a strong art school at the Institute of Technology. In the 1920s, the Institute offered evening classes in commercial art for teachers, and in 1926 the first day-time classes in commercial art were offered by Norwegian artist Lars Haukness. When Haukness died unexpectedly in 1929, Carpenter had to find a replacement. He contacted Leighton and persuaded the tall, slim Englishman to head up his embryonic art school.

Leighton arrived in Calgary in November 1929. There he took the Institute's modest program in painting and developed it into what is now the respected Alberta College of Art. In 1933, as part of his plan, he invited a group of promising Calgary students and painters to work with him for three weeks at Brewster's dude ranch at Seebe, Alberta, just where the foothills and mountains meet.

For Ace, working in the mountains was a dream come true. His hometown paper, the Hastings *Observer*, said of its favourite son:

From earliest boyhood, Mr. Leighton had dreamed of the time when he would come to Canada, where he hoped to become a cowboy and ride the ranges. And the dream has partially materialized, for although he has not become the romantic rancher that his boyhood dreams would have made him, with pack horses and guide [he] has explored some of the finest miles of mountain scenery.

Although plagued throughout his life by ill health, Ace Leighton loved the out-of-doors, and working in the midst of the towering Rockies was a dream come true. He was most at home on the trail or around a campfire. He hated crowds, and had welcomed the chance to move to Calgary, the small, raw cow-town within sight of the mountains he loved. Modest almost to a fault, Leighton was described as tall, handsome, and endowed with an aristocratic charm and a delightful English accent. He had a shy reserve. His face was lined, his expression indomitable. He had a passion for his profession. "I paint because I must. I paint from twelve to fourteen hours daily. Wherever I go I see something to paint – flowers, bottles – anything. It is a disease."

One of his first students was a young man named Bernard Middleton, then managing a drafting and blueprint company by day and taking art courses at night. Middleton had a gift; Leighton spotted it and encouraged him, as Middleton well remembered: "As long as you were interested, he would work with you. He had just one interest in life and that was furthering the cause of art, and he was totally wrapped up in the work, and therefore the lives, of his students. He knew how many of them were having difficulties and he did everything he could to help them out in the most unobtrusive way."

When he started at the Institute of Technology and Art, Leighton had eight pupils; a year later the number grew to fifty-eight, and the year after that he founded the Alberta Society of Artists and became its first president. The *Calgary Herald* commented editorially on the growth of the art school and congratulated both the Institute and Carpenter for their vision in securing Leighton for Calgary. The editorial stressed the importance of "a serious endeavour to establish Calgary as a centre for art in the northwest."

That same year, in a small and private ceremony, Leighton married Barbara Mary Harvey, one of his students. Their honeymoon was spent backpacking in the Kananaskis Valley west of Calgary. Later in the year, Walter Phillips travelled to Calgary to visit the newlyweds. Phillips describes arriving at the railway station but having to wait because Leighton drove all the way in to the city with his emergency brake on. "Leighton, though a beautiful painter, is an indifferent chauffeur," Phillips remarked drily. "He finds it difficult to keep his eye on the road and his mind on the job."

Phillips was much more impressed by Leighton's work: "He took only two to two and a half hours to do a watercolour sketch. The drawing alone, always impeccable, would represent half a day's work for most men. Yet he never exceeds his time limit."

Leighton had an obsession with standards, and he would never sign his own work unless he was ready to exhibit it. Anything that fell short of his expectations he destroyed. The result was that only a few of his finished works – among them some of the finest paintings ever done of the Canadian Rocky Mountains – survived.

At the time, appointments at the Institute of Technology were for the full year, and to receive their salaries, staff members were required to keep themselves busy during the summer months even though there were no students on campus. Leighton believed strongly in sketching from nature, and his answer to the summer hiatus was the sketching course, conducted at Brewster's dude ranch at Seebe. Among the first class of 1933 were Stan Perrott, Bernard Middleton, and Marion Nicoll, all of whom were to become prominent artists. "We had a marvellous time there because we slept in these bunk houses and went to a communal breakfast and jostled around with the cowboys," Perrott recalled.

Buoyed by the success of the inaugural summer session, Leighton expanded the school in 1934 by inviting students from Edmonton and Regina. The program was much welcomed by novice painters, and some went to incredible lengths to attend. The

Alfred Crocker (Ace) Leighton.

story is told of one dedicated aspiring artist who could not afford to pay for transportation and walked all the way from the small town of Trochu on the prairie to the dude ranch in the mountains. She carried her painting supplies in a pack and slept one night propped against a telephone pole.

In 1935, Leighton moved his classes from Seebe to Banff to share facilities with the young Theatre School run by Elizabeth Sterling Haynes. So began the School of Fine Arts where the juxtaposition of the various artistic disciplines has been a key feature ever since.

The art school was housed in the high school, but students spent most of their time out-of-doors. The staff in those early years, including Arthur Adams, Leo Pearson, Bernard Middleton, Geo Glyde, and Leighton himself, were mainly from the Institute, and their salaries were covered by the Institute's contract.

Stan Perrott, who went on to Banff with Leighton, remembers going out each day to sketch, usually to Bow Falls or the boat house. The big event was being driven to Castle Mountain. Middleton, who was instructing, had a car, and the students would vie for the place of honour in the front seat next to him. One of those students was Roloff Beny, later to become internationally acclaimed for his work in another medium, photography.

Leighton taught only one year at Banff. Never robust, he went to England with Barbara for a rest and to do some painting. He did not return to his teaching post, which he resigned in 1938. After living for a time in British Columbia, the Leightons resettled on land just south of Calgary, where they lived until his death in 1965.

His place at the Institute of Art and in Banff had been taken by another English-trained painter, H.G. (Geo) Glyde. He established the Art Division at the University of Alberta in 1947 and was to spend thirty summers in Banff. More than anyone else, he was the builder who took Leighton's dream and made it a reality.

Geo was an affable, outgoing man whom Leighton had known in England. When the need for a strong drawing instructor at the Institute became apparent, Leighton wrote immediately to Glyde. After spending most of his contract year in Calgary, Glyde was preparing to return to England when he was taken on a trip to Bow Lake. His daughter Helen reported, "He came back and said, 'We can't go back yet, you know – we've got to look at this a little more.' So we decided to stay another year." The year was extended and he and his family settled permanently in Canada.

Glyde was a master of drawing, and unlike Leighton, he had a strong interest in life drawing. He introduced nude models to the Art Institute in the mid 1930s, thereby rousing a storm of protest from the ladies of the Baptist church, of which Carpenter was a member. Caught up in the tempest, Carpenter privately told Glyde to go ahead, but took an official position against using nude models. Much later, Glyde introduced life drawing in Banff, with less controversy.

Because Leighton and Glyde had both come directly from Britain, neither had spent much time

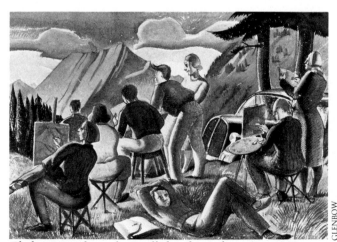

Glyde watercolour of a Banff sketching class, circa 1940.

H.G. (Geo) Glyde with students, 1946.

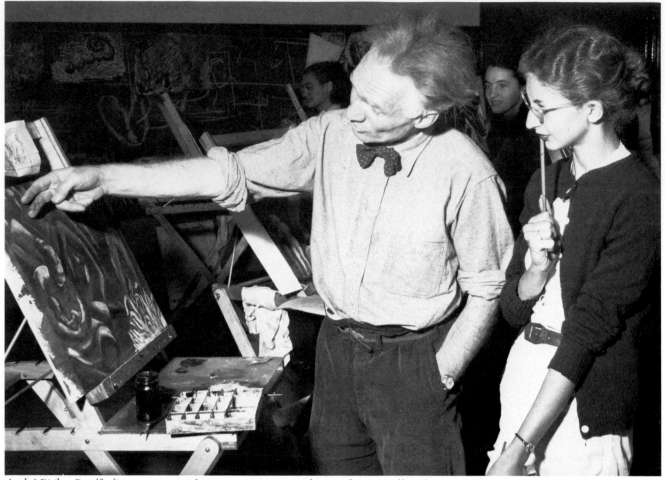

André Bieler, Banff's first contact with eastern painters. Bieler taught at Banff on four occasions.

in eastern Canada, and their contacts there were limited. In 1940, however, the east came west. Dr. Robert Wallace, President of the University of Alberta when Corbett launched the Banff School, had subsequently moved to Queen's University in Kingston, Ontario, as Principal. On the Queen's faculty was a dynamic, articulate artist-in-residence from Quebec named André Bieler. Wallace recommended him to the school's directors, and Bieler arrived in Banff in the summer of 1940. He found it a revelation that these English-trained westerners knew so little of what was happening in the rest of Canada, and he set out to correct matters. In the years to follow, easterners like A.Y. Jackson, Charles Comfort, Jock Macdonald, and others were to make Banff their summer home.

Art and drama co-existed at Banff in 1935, but each operated in isolation from the other. In 1936, active administration of the summer schools in drama, music, and art were combined in the Banff School of Fine Arts. It was in that year that Donald Cameron became Acting Director of Extension at the University in Edmonton and took charge of the Banff Summer School, opening another chapter in its development.

5

The Master Builder

Donald Cameron's graduation photograph, University of Alberta, 1930. The yearbook caption said: " Possessed of a high degree of executive ability, of maturity and mental backbone above the ordinary, of a genuine friendliness and of a temperament which cannot tolerate that which is petty or small, Don has shown that he has the things which go to make up a leader."

Thomas Carlyle once wrote that "the history of the world is but the biography of great men." Certainly the history of the Banff School owes much to the men and women who dared to dream. But the master builder was clearly Donald Cameron, who, during thirty-three years, transformed their visions into an internationally acclaimed institution.

Donald was a product of the prairies, but he took pride in his Scottish roots. On ceremonial occasions he donned his Cameron kilt, and the sound of pipes echoed frequently through the campus he created.

He was a farm boy, brought to Alberta from Scotland in 1906 when he was five. The family settled on a farm at Elnora, two miles south of the town of Innisfail, and broke the virgin prairie sod. It was a hard life. Money was scarce and entertainments few, and the Cameron children sometimes had their morning oatmeal served up again at dinner after a two-mile hike home from school. But hardship created a close family and built character that served Donald well in the years to follow.

Not long after they arrived, Donald's father became active in a social movement known as the United Farmers of Alberta. When the UFA took a political turn, Cameron senior became president of the Innisfail provincial constituency association, and in 1921 was elected to the provincial legislature, where he served for fifteen years.

With his father away much of the time, Donald, the eldest son, took over management of the farm. From the time he left school at age fifteen until he entered university ten years later, Donald ran seventy head of cattle, seeded and harvested the crops, and managed the finances. The experience he gained building the family farmhouse gave him practical knowledge that was useful in later years when he personally supervised the construction of much of the Banff School campus. He learned how

to manage money, and he developed a lifelong practice of making do with what was on hand. At the age of twenty-four, however, he became disenchanted with farm life:

> The quality of the crops was good, all grading Number Two Northern. While it had been a most satisfactory year and a marvellous fall, there was one great drawback. There wasn't a market for the wheat. We decided to ship the wheat to Fort William [now Thunder Bay] and hold it in storage and not sell it. It cost six hundred dollars a car to ship 1,500 bushels to Fort William, and the storage, before we sold it, amounted to about the same amount, so that by the spring of 1925, when we were able to settle up the returns for the 1924 crop year, I found that the CPR and the elevator companies had got more out of the crop than I had, and that was the deciding factor in my determination to leave the farm.
>
> I had come to the conclusion that I was spending my life working for the machine companies, or the railway companies, or the elevator companies. They were the ones who were getting the gravy and I was getting the hard work. I decided I had had enough of that!

In the winter of 1925, Cameron took correspondence courses in history and economics through the Department of Extension of the University of Alberta. To his surprise, he won a prize of $250, tenable at the Olds School of Agriculture. He asked permission to transfer the scholarship from Olds to the University of Alberta, and in September 1926 he enrolled as a freshman in the Faculty of Agriculture. Later, he said: "Going back to the university was like going home, because I had been at every farm young-people's week from 1920 until the spring of 1926. I knew, personally, every member of the faculty."

He was twenty-five when he went to university, and he involved himself in student activities right from his first year. He was on the track and soccer teams, head of the Debating Society, Director of the university yearbook, and in 1929 was elected President of the Students' Union.

During his presidency, Cameron was also Chairman of the Student Disciplinary Committee. In this position, he made an acquaintance who was to have a considerable later influence. The President of the Drama Society that year was a very lively and talented girl named Elsie Park Gowan "who usually found herself on the opposite side of the fence in almost anything I was trying to do," Cameron wrote.

Being an innovative type, Elsie wanted to have a party to wind up the drama season and she wanted to have it over in town at one of the hotels or restaurants. This was against the rules. But this didn't deter Elsie, so she proceeded to take her group and hold her dinner over town. In due course, she was hauled before me to answer for her sins and I promptly levied a fine on her of fifteen dollars cash.... Elsie first tried to have the fine paid by the Drama Society, and again, as President of the Union, I forbade this, and then she ingeniously passed the hat among her colleagues and collected the fine in that way. And, after all, there wasn't much I could do about that.

Elsie Park Gowan was later to become a faculty member at Donald Cameron's Banff School, and a leading Canadian playwright. She was a friend and adversary of Donald's all her life, and a constant thorn in his side by her own admission. She expressed the view that this "Aggie" from Innisfail would never understand or appreciate the fine arts, and she once predicted a grim future for him at the Banff School. In later years she reflected, "Perhaps my jibes ... helped turn Donald into a great friend of the fine arts just to show me how wrong I was."

Donald's student career brought him to the attention of the university authorities, including Ned Corbett, who had stayed at the Cameron home in Elnora on several occasions when he lectured in that community. Corbett offered Cameron the job of Agricultural Secretary in the Department of Extension after he graduated. Cameron accepted and joined the university staff on October 1, 1930, having worked the summer as an agricultural field representative.

At age twenty-nine, Cameron was taken under the wing of "Tiny" Ottewell, Ned Corbett, and his namesake, D.E. Cameron, who was Librarian of the university. To Donald's delight, these three men "shared a belief in the capacity of ordinary people to do unusual things. They each had the great gift of being able to talk on a man-to-man basis with people, whether they were lumberjacks in bush camps, miners in mining camps, farmers, housewives, women's institutes or more sophisticated people in the towns and cities They were warm and friendly people who were dedicated to doing everything they could to improve the intellectual life of the people of the province."

Donald describes going hunting on lazy, warm fall afternoons with Ned Corbett, and playing "hole-at-any-price" golf with the others at the Mayfair Golf Club. But they worked hard, and none harder

than the new Agricultural Secretary. One of his jobs was to organize lecture programs on agricultural topics, generally using members of the Faculty of Agriculture, prominent farmers or members of the provincial Department of Agriculture staff. The Secretary himself was expected to take his share of the country lectures, so Donald Cameron joined the extension team with their Model-Ts and Magic Lantern shows.

Cameron setting out on the Magic Lantern circuit, early 1930s.

His time on the lecture circuit gave him a sincere appreciation of rural people and the hardships they faced in those difficult Depression years. He stayed with them in their homes, often under what he described as "primitive conditions," and he counted those times as among his "richest experiences."

It was during his extension rounds, speaking on agricultural topics, that Cameron first became aware of a hunger for the arts. He was often asked whether the university could not do something to foster appreciation of literature, music, theatre, and art: "The constant quest on the part of the people in the outlying communities was for some means of providing a richer intellectual climate for the young people who were growing without the opportunity."

In the summer of 1932, Donald married Stella Ewing, a neighbour from Elnora days. The following year, he went to Europe on a Carnegie scholarship to study educational methods in the Scandinavian countries. In particular, he was impressed by the Danish *Folkehøgskoles*, or folk high schools, a movement started in Denmark for children of farmers who had no access to secondary education. Admission was not dependent on the student's ability to pay; desire for learning was the only criterion. Much of the philosophy Cameron was later to apply in building a community-oriented school in Banff

originated in his observations of the Danish system.

It was at this time that the Canadian Association for Adult Education was formed. When Ned Corbett left for Toronto to assume the directorship of the CAAE in 1935, Donald became Acting Director of the Department of Extension at the University of Alberta. He didn't have the missionary training of his predecessors in extension, but he did possess a spirit of commitment and an inclination to work hard. Although he had no background in the arts – and this fact was constantly to be thrown in his face in the years that followed – he learned quickly and threw himself into the job of building a great school at Banff. Elsie Park Gowan later wrote: "It is well to remember that this fellow's plain talk has paid the shot for other people's sonatas; his businessman's solidity built the stage under Titania's fairies."

Although Cameron was not, strictly speaking, a businessman, he had a businessman's instincts. He travelled in business circles and made himself at home with the leading industrialists of his day. To them, he was constantly selling his dream; from them, he was always soliciting money to help make that dream come true. His single-minded devotion to that cause stood him in good stead through the difficult Depression years. Faced with opposition or indifference and regardless of criticism and well-meaning advice, he stuck steadfastly to his goal. He became a skilled fund-raiser and, in his own words, "a professional scrounger." When Cameron joined the National Film Board, he used the board meetings as a means of paying for his travels to eastern Canada, where he recruited faculty. And later, as Senator, he used his travel pass to help foot the bill for fund-raising forays to corporate headquarters in Toronto and Montreal.

In 1939, Bretton Hall, the original theatre in Banff, was condemned to be torn down to make way for the new Parks Administration Building. The loss of so essential a facility could be crippling, and Cameron set to work at once to arouse community support for a new auditorium. Against considerable opposition, he mounted a successful campaign to raise $150,000, and on January 5, 1940 the new Banff Auditorium was officially opened. The university had contributed $20,000 to building and equipping the stage, in return for which the Banff Summer School was to have the use of the auditorium without rent for ten years.

Cameron next turned his attention to the need for a dining hall and settled on an old garage, in which the Brewster Transport Company had overhauled and painted its buses. With the help of vol-

The Banff Avenue Auditorium, opened in January 1940 and home of School productions until 1968.

Brewster Hall on Banff's main street was the dining room during the forties.

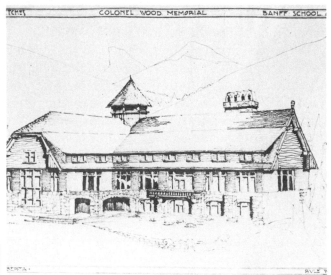

John Rule's revised sketches of the planned building. At this point Donald Cameron had a pledge of $50,000 from the Colonel Woods estate, and no definite site.

unteer labour, he scraped, washed, and painted the old hall; it was ready for use by the opening of the 1946 session. In the same year, he negotiated with the War Assets Corporation for the purchase of six huts from a former prisoner-of-war camp in the Kananaskis Valley, just thirty miles from Banff. He bought them all for $350, then persuaded the supervisor of a camp for conscientious objectors in Seebe to have his staff take the buildings apart and load them on trucks for shipment to Banff. The transportation bill was a negligible $150. On July 10, 1946, the first dormitory of the Banff School, Bungalow Court, was opened.

It was at this time that Donald Cameron met an individual who was to play a most influential role in the growth of the school. Eric Harvie of Calgary, then a prominent lawyer, later became one of the wealthiest men in Canada. He created the far-sighted Devonian Foundation, which donated parks to many cities, and he was one of Canada's most enlightened benefactors. But in the mid-forties, as legal advisor to Mrs. J.H. Woods, widow of the publisher of the *Calgary Herald,* Harvie was looking for an area of interest for the Woods estate, and at Banff he found it.

Donald Cameron described the occasion of his first meeting with Eric Harvie – a meeting that was to prove a turning point in the development of the School.

At three o'clock on a lovely autumn day in September 1945, I went up to Mr. Harvie's room in the McDonald Hotel [in Edmonton]. The room looked out over the valley of the Saskatchewan, which was then in all its autumnal glory of colour. It was a beautiful sight, and as we talked Mr. Harvie frequently looked out over the valley. We had exchanged the usual pleasantries and finally he said "Now tell me about this Banff School of yours." I didn't know how much he knew, but I was determined to give him the best story I could. . . . Mr. Harvie listened with equanimity and said, "Oh yes, I know you need money, but tell me what you would do if you didn't have to worry about money?" Well nobody had ever said that to me before, and as I didn't know Mr. Harvie very well then and didn't know whether he was serious, I stamped my foot and cried, "But I've got to have money; this can be the biggest thing in Banff and I want a million dollars." Eric Harvie was standing up looking out over the river valley, but as I said, "I want a million dollars," he swung around, snapped his fingers and said, "That's the kind of thing that interests me.

What would you do with a million dollars if you had it . . . ?" After more discussion, questions and answers, Mr. Harvie said, "I like your story, I like your enthusiasm, and I believe you have something in Banff which could interest me very much. You can count on $50,000. Let me see what you can do with that."

Typically, Cameron went straight from the meeting to the university architect, John Rule, and told him he had $50,000 for a building for the Banff School. But, he told Rule, "$50,000 is not enough. Pay no attention to that; this is what I need: I want a building that will provide a dining room for 300, sleeping quarters for at least 150, and classrooms for the same number."

With the drawings Rule provided, Cameron went to Ottawa to see Roy Gibson, then Director of National Parks of Canada, to whom he showed his drawings and made his pitch. After discussing the project from various angles, Gibson finally said he would give Cameron anything within reason. Cameron asked for three lots of land on Deer Street on the northern approach to Banff townsite. Gibson agreed.

Returning to Banff, Cameron and Harvie walked the Deer Street site and also examined a parcel of land then known as the St. Julien site, situated

Eric Harvie believed in the Banff dream.

immediately above the town on Tunnel Mountain. The St. Julien site excited them at once. The Banff Park Superintendent, Major Jennings, frankly admitted there was no finer property in Banff, but he doubted that Cameron would get it. Undaunted, Cameron and Harvie decided that the St. Julien site was the right one and that they should hold out for it, whatever the odds.

On his next trip to Ottawa, Cameron spoke again to Roy Gibson, this time asking for the St. Julien site. After a sometimes heated discussion with other officials, Gibson abruptly interrupted the conversation: "Cameron, we believe in your proposition. If the plans you have outlined for Banff are what you and your associates have in mind, you can have any help we can give you." National Parks agreed to grant the school a perpetual lease on the forty-one-acre St. Julien site for the sum of one dollar per year. In addition they agreed to lay in sewer and water services and to provide roads and walks.

Cameron was elated: "The acquisition of the St. Julien site was a major achievement in the devel-opment of the School, which greatly assisted and encouraged us to proceed with our plans to lay the foundation for a long-range and permanent institu-tion. There were further discussions with Mrs. Woods and Mr. Harvie, and on May 3, 1946, Mrs. Woods advised that she would increase her gift to $100,000 for the building of the Administration Building of the Banff School." Within a matter of months, Cameron had acquired a campus and a healthy building fund.

One lovely summer afternoon in 1946, Donald took the school – faculty and students – to the St. Julien site for a picnic. He had a piper play as the twilight gathered, and he talked of his dreams and plans for the future. Elsie Park Gowan, who was there, called it the "birthnight" of the Banff School.

In subsequent years, Cameron carried on a per-sistent search for funds for the growing school. He took great pride in repeating the story of how he wandered up and down "the highways and byways of Canada, rattling my little tin cup for contribu-tions." He often built before he knew where the money was coming from. Several times, construc-

"The Birthnight of the Banff School," August, 1946. Donald Cameron held a picnic on the undeveloped St. Julien site to tell staff and students of his plans. Student Frank Buchanan of Blairmore, Alberta, played the pipes in honour of the occasion.

38

tion was halted while Cameron hurried out to raise enough funds to continue. It was never easy, and the university was little help to him financially – it had needs of its own. So he built in hand-to-mouth fashion, and he learned every trick on how to cut costs.

He loved building. It was one of the great joys of his life to work on the design of a new building and to see it take shape. That he accomplished so much with so little money is a miracle. He did it with a combination of gall, single-mindedness, and boyish enthusiasm that inspired others to help as well. He had a plan in mind, and he knew what he wanted. Cameron was no ivory-tower leader, and he never hesitated to roll up his sleeves or don overalls to pitch in when something needed to be done. It was this quality in him that inspired loyalty from a generation of staff for whom "The Old Man" could do no wrong.

His single-mindedness likewise stood him in good stead in obtaining the best-qualified faculty for his growing school. He sought out the very top people, charming them with his directness and

sense of mission; only later in the conversation would he drop the bad news that he could pay them only half of what they could earn anywhere else. Curious and bemused, most of them came anyway.

All was not sweetness and light, however. Some of his critics accused him of empire-building. Artists occasionally bridled under what seemed to them an authoritarian management style. Cameron set that style and the atmosphere was not congenial to everyone. Dinner, for example, was always a fairly formal affair. Cameron said grace, and students were expected to be properly dressed or go without meals. It became a game to see who could short-circuit the rules. Harold Baldridge, a student in 1958, remembers rushing from scene-painting to dinner, his hands washed but the rest of his body – under his shirt and tie – splattered with barely dry paint.

Shirley Tooke, then a student who later became a Drama Faculty member, recalls that the girls would try to sneak in at the back in shorts. A moment of tongue-in-cheek triumph was achieved when one drama student, invited to sit at the Director's table,

Opening ceremonies for the first chalets on the St. Julien campus. Mrs. J.H. Woods in foreground right. Ann Graburn of Calgary, a student in painting, is the speaker.

39

arrived in white tie and tails! Cameron often lectured the students on their standard of dress and manners and once generated considerable muttering when he implied that the American students were inferior in that respect to their Canadian counterparts. His residences were supervised by Mrs. Cameron and a group of matrons, who levied small fines for minor misdemeanours, and who were constantly driven to distraction by the free-spirited students.

To his credit, Cameron had the sense to hire good faculty and then leave them alone. The only thing he could not abide was a lack of commitment in those he hired. One well-known British acting instructor, a brilliant lecturer, taught one year and was never asked to return. Cameron faulted him for neglecting his students outside of class hours.

In spite of criticisms, unilateral decisions, and the inevitable bruised egos, everyone felt a sneaking respect for the man, if not a genuine sense of awe. They knew what he had done, and they admired him for it. Although some might not agree with how he accomplished what he set out to do, they knew he put the best interests of the School above all else.

In 1952, with buildings sprouting on his campus, Donald Cameron seized an opportunity in another sphere of education. Several leading universities in the United States and Canada had established continuing-education courses in business management, and he saw that such courses could make use of his buildings in the winter months. Better still, they would pay their own way. Through the Department of Extension, he initiated a six-week program in Advanced Management, employing, in the main, university faculty to teach senior admin-

Donald Cameron welcomes Queen Elizabeth and Prince Philip, 1959. Banff Park Superintendent Harry Dempster looks on.

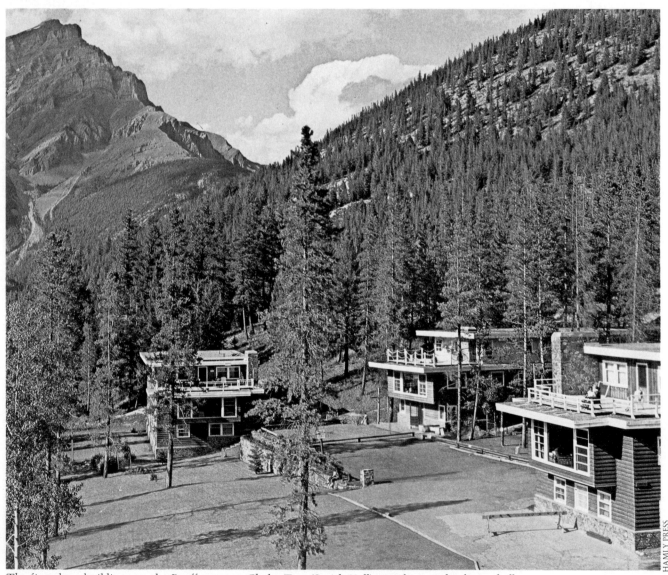

The first three buildings on the Banff campus. Chalet Two (Smith Hall) at right was the dining hall.

Cast for Othello, 1963. Seated (l. to r.): Jeannette Marley, Irene Prothroe. Standing (l. to r.): Gary Mitchell, Donovan Marley, Alan Robertson.

Charles Werner Moore, noted acting instructor from Brandeis University, was a regular faculty member in the 1970s.

Douglas Campbell directs cast in A Flea In Her Ear, *1977.*

was a young actress named Olga Laruska, who later changed her name to Diane Foster and went on to a successful career in Hollywood.

Many of those Banff students became participants in an early attempt to establish professional theatre in Canada. Sydney Risk dreamed of starting a professional acting company based in Vancouver, which would tour western Canada. He put together a company that consisted partly of actors from Banff, and in January 1947, the group climbed on a battered bus to begin a tour that was to take them from Vancouver through to Winnipeg, then back to Saskatoon and Edmonton. The company was called Everyman Theatre, and a list of its members reads like a Canadian acting *Who's Who*: Arthur Hill, Ted Follows, Murray Westgate, Ed McNamara, Esther Nelson, Lois McLean, Drew Thompson, and Peggy Hazzard. It was the first professional company in the west, and when it folded after its first year, Sydney Risk left the Banff School. But he left a legacy in the memories and experiences of many of Canada's finest actors and actresses.

At the end of the war, enrolment at the Banff School grew rapidly. New programs and courses were introduced. In 1947, a course in ballet was offered to the drama students, using instructors from the Winnipeg Ballet. Although dance is now a separate division, movement and fitness still play a large part in an actor's training at Banff.

Among the post-war staff were three women whose careers at Banff were to be closely intertwined over the next thirteen years. Esther Nelson and Leona Paterson joined the summer staff in 1946. Evangeline (Van) Machlin took Leona's place as speech instructor in 1949, and for a number of years the names of these two brilliant women were synonymous with speech training at the School. Meanwhile, Esther was a regular summer faculty member, becoming head of the Drama Division in 1949 when she also became head of the Theatre Division at the University of Alberta's Extension Department. She was to remain at the Banff School until Gordon Peacock, head of the Drama Department at the University of Alberta, became Banff's Department Head in 1958.

That year, and the production of *Much Ado About Nothing*, were special events in the history of theatre at Banff. For one thing, it was the School's twenty-fifth anniversary. For another, Peacock invited the distinguished B. Iden Payne to direct the annual production, and his *Much Ado* was one of the School's great critical successes. Virtually everyone connected with it was to play a significant role in the future development of the School.

The two lead parts of Benedict and Beatrice were played by Gordon Peacock and Irene Powlan, who as Irene Prothroe later became Head of Drama at Banff. Tom Peacocke played Leonardo. A young Calgary girl, Mary Humphrey, appeared as Hero, and Hero's uncle, Antonio, was played by another University of Alberta student, Harold Baldridge. Later, as Mary Humphrey Baldridge, she was to become a prominent poet and playwright, and her husband, Harold, went on to direct theatre companies in Calgary, New York City and Woodstock, New York; he also taught at Banff.

Iden Payne, then in his eighties, had come to the mountain School in the declining years of his life. He had enjoyed a glittering career in British theatre, heading up Dublin's Abbey Theatre and the Stratford (England) Theatre before moving to the United States to teach at Carnegie and the University of Texas. But it was in Shakespearean theatre that he had made his reputation.

One student described Payne as having a more intimate relationship with Shakespeare's characters than he had with any living human being. During

Fiona Reid played a lead part in All My Sons, *produced in 1971.*

48

Movement class for the Drama Program, led by the famed Paul Draper.

one class, when Payne was discussing *Romeo and Juliet*, his students became absolutely spellbound as this eighty-year-old man was transformed into a fourteen-year-old girl before their eyes. His eyesight was failing, and when he directed, he needed field glasses to see the actors on stage. But his mind was alive and sharp, and he returned to Banff for five more years. He was an inspiration to a whole generation of actors now prominent in Canadian theatre.

Two of Payne's players in *Much Ado* led a personal life at Banff that was almost as complicated as Shakespeare's plot. Mary Humphrey and Harold Baldridge had met at the University of Alberta and had decided they would marry that summer in Banff. Harold recalls that they attended classes together all morning, worked on sets and costumes in the afternoon, and rehearsed their roles in *Much Ado* at night – not the customary preparation for a wedding!

Harold's role as Mary's uncle in the play required him to give her away in marriage. The afternoon before the final performance of *Much Ado*, Harold

and Mary themselves were married in the little Anglican church in the town, a nervous Gordon Peacock giving the bride away. The newlyweds went on stage that evening as usual, although they were excused from the chore of striking the set so that they might spend their honeymoon at the Banff Springs Hotel.

Peacock ran the summer Drama School for seven years, during which time he brought many top people to Banff, including Payne, Prothroe, and the noted Texas director Francis Hodge. When Peacock left, Prothroe became Head of Drama in 1965. She ran both Drama and Musical Theatre for several years, then left to become a radio producer with the CBC. A tough, outspoken, and demanding teacher, she supervised some of the Banff School's most exciting productions.

The 1971 production was Arthur Miller's *All My Sons*. One of the leads was a blonde girl from McGill University named Fiona Reid. Fiona had absolute devotion to her profession. When she learned that the production dates of the play conflicted with her

sister's wedding, she chose to stay in Banff for the performance and miss the wedding. She went on to professional roles in Toronto, including work at Stratford and in television. Banff, she says, provided "invaluable experience and teaching in what acting was all about. It was where I first worked in 'the method,' and on voice and movement in a concentrated way . . . it got me started on the right foot."

In 1972, Tom Peacocke came back to Banff – this time not as a student, but as Head of Drama. Tom had gone from Alberta to train at Carnegie-Mellon University in Pittsburgh, one of the best theatre schools in North America. He returned to Edmonton to teach at his alma mater, and made a name for himself acting and directing at the University of Alberta and at the professional Citadel Theatre. On Gordon Peacock's recommendation, he became Head of the Banff Drama Program in 1972. The young student who had been so influenced by Elizabeth Haynes was running the program she had begun forty years earlier!

Peacocke brought fresh vigour to the department, commissioning new plays from Canadian writers, introducing clear-cut levels of instruction, and attracting talented new faculty members. These included Paul Draper, from Carnegie-Mellon, for movement; Pierre Lefevre, from the National Theatre School, Charles Werner Moore, from Brandeis, and Harold Baldridge for acting; Douglas Campbell, Howard Dallin, and Malcolm Black, to direct; Van Machlin, Kathleen Stafford, Edith Skinner, and Tim Monich, for speech.

Among the new plays Peacocke commissioned was *Sunrise on Sarah*, written by George Ryga. When it was premiered in August 1972 at Banff, Prime Minister Pierre Elliott Trudeau and his wife, Margaret, were in the audience. After the final curtain, the Trudeaus joined the cast party and stayed late into the night chatting with the excited performers.

Peacocke reluctantly left Banff at the end of the seventies, in order to spend more time acting. He handed over the Drama Program to Jim McTeague, who had also taken over as Head of the Drama Department at the University of Alberta. McTeague thus continued the line of succession that had started in 1933 with Elizabeth Haynes.

7

Always Go For the Best

A favourite photograph in Donald Cameron's files is one taken in the summer of 1947 on the steps of the old Banff High School. It shows Donald with Dr. Robert Newton, the President of the University of Alberta, Mrs. Newton, and the creative writing staff of that year: novelist Hugh MacLennan, Dr. E.P. Conkle, Head of the Department of Playwriting at the University of Texas, and Mr. and Mrs. Norman Corwin of New York. A more distinguished group would have been hard to find.

Robert Kroetsch, who has twice won the Governor-General's Award for Literature, came to Banff as a student that same year, a raw farm boy from Saskatchewan. He remembers his awe at meeting MacLennan, and how that meeting inspired him to make writing his vocation.

The 1947 faculty group was typical of Cameron's determination to "go for the best." He once wrote, "In buying any commodity the experienced buyer usually realizes he will get exactly what he pays for. This is true whether he is buying groceries or education, only in education, the cost of buying an inferior article is enormous. . . . Good instructors attract and make good students, and the return on the investment is incomparably higher than in buying an inferior article."

Cameron had persuaded the noted Frederick H. Koch, from the University of North Carolina and founder of the famous Carolina Playmakers, to teach at Banff in 1937, and Koch set off a burst of creativity in playwriting that was remarkable for the period, and has seldom been rivalled since.

At the time of Koch's death in 1942, Donald Cameron approached the Rockefeller Foundation

The 1947 Writing Faculty and friends. (l. to r.): Donald Cameron, Hugh MacLennan, Mrs. Norman Corwin, Norman Corwin, Mrs. Robert Newton, E.P. Conkle, Dr. Robert Newton (President of the University of Alberta).

for funding to gather the local history and folklore of the western plains. The history was planned as a direct outgrowth of Koch's philosophy of plays springing from local roots.

Robert E. Gard was then in charge of a folklore project, funded by the Rockefeller Foundation, at Cornell University. His background was ideally suited to Cameron's needs, and Gard was engaged as instructor in playwriting for the 1942 summer session at Banff. He suggested to Cameron that they submit to the Foundation a project similar to the one on which he was working at Cornell. This was done, and in 1943, the Foundation made a one-year grant of $5,000 to the university and the Banff School for the establishment of the Alberta Folklore and Local History project. Gard was engaged as Director of the project following the 1943 session of the Banff School. The project was later extended for another two years.

Gard travelled around Alberta collecting material, which became the basis of the *Alberta Folklore Quarterly*, published from 1943 to 1945. The stories he recorded formed the core of a series of half-hour radio shows broadcast on the national network of the CBC. Gwen Pharis Ringwood was Project Assistant, charged with the specific responsibility of writing at least three one-act plays based on native material. *Jack and the Joker* and the full-length *Stampede* emerged from her work.

A two-week Alberta Writer's Conference was organized in 1944 and was subsequently incorporated into the course in Playwriting, Short-Story and Radio Writing in the Summer School program. In 1946, E.P. Conkle took over from Robert Gard and the following year Norman Corwin came to Banff for the first time.

The names Conkle and Corwin were to appear frequently in the Banff Summer School calendars over the next ten years, along with others like

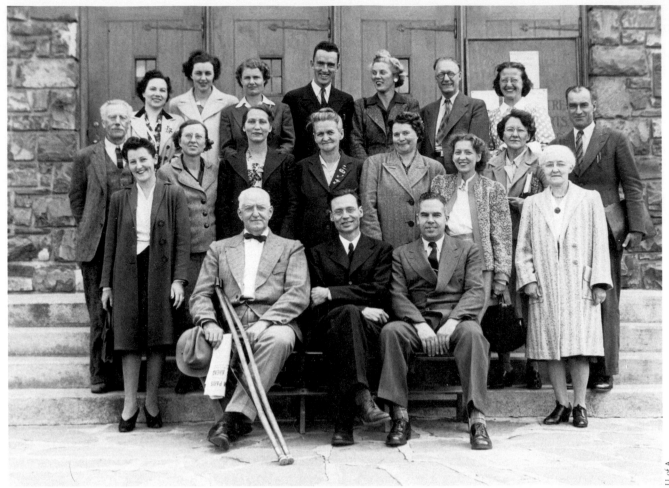

The First Alberta Writers' Conference, held at Banff, August, 1944. Robert Gard is seated, centre. Donald Cameron is on his left. Standing behind Cameron are Gwen Pharis Ringwood and Miss J.F. Montgomery. The dark-haired gentleman in the centre of the back row is John Patrick Gillese, now Director of Film and Literary Arts for Alberta Culture. Elsie Park Gowan is on his left.

Jerome Lawrence and Robert E. Lee – two protégés of Corwin's, who later wrote a number of Broadway hits, including *Inherit the Wind* – and Mavor Moore, now Chairman of the Canada Council.

Corwin's presence at Banff was proof of Donald Cameron's skill in persuasion. In the post-war era, Corwin was at the top of his profession in radio; one writer said that Corwin was to American radio what Marlowe was to the Elizabethan stage. Radio writing in Canada was especially important, for radio provided the stage for Canada's national theatre. At that time, there was no other.

Norman Corwin was internationally renowned for imaginative and creative radio writing, and was much in demand. When Cameron decided he wanted someone to take charge of the annual Writer's Conference, he went after Corwin. Typically direct, he arranged an interview at Corwin's New York apartment.

Corwin recalls that they met on a beautiful autumn day, "the parade of towers along Fifth Avenue and Central Park West marching off in the general direction of Canada." He had never heard of Donald Cameron or the School, and was only vaguely familiar with the area of Banff. Cameron straightforwardly invited him to teach a course at the School of Fine Arts the following summer for what amounted to a fraction of Corwin's normal fee.

"I had no right to accept," said Corwin. "I was under a heavy schedule of broadcasting commitments, stretching ahead for two years. But there was something regal – in the best sense – about my visitor, and one does not lightly decline a command performance. I went."

Corwin came, saw, and was conquered. He became caught up in the Cameron dream and in the potential of the little School in the Rockies. He loved his time there, and was to return on four other occasions. His participation put an instant stamp of quality on the School's writing program.

One summer, when Corwin had been booked to come, he had to cancel at the last minute. Donald called on his old *bête noire* from the university, Elsie Park Gowan, to stand in for the great man.

Elsie was delighted. She had spent the previous summer at Queen's University working on radio writing, and she relished the challenge.

There was a very talented girl from Edmonton in the drama class that year. Her name was Merna Hirtle, and Elsie was so impressed by her she later used Merna in many of her radio plays. "The first series I had on the CBC was called 'The Building of Canada,' and Merna was every heroine from the siege of Quebec to the discovery of radium in the north. She was awfully good. I remember her telling me she had a good friend who was trying to write short stories."

Merna ended up marrying her "good friend," a budding young writer named W.O. (Bill) Mitchell.

In 1952, another Texan came to Banff. Sylvan Karchmer, a well-known writer and editor, was Conkle's colleague at the University of Texas. He was to come to Banff, off and on, until 1972. Karchmer recalled his rather inauspicious debut:

I arrived in Banff that first summer as a rather awkward young instructor with a certain doctrinaire approach to the subjects I taught. I think I must have been as much in awe of my students as, perhaps, they were of me. In any event, classroom procedure was rather stuffy. After several sessions of the class, a young girl, who came from Montreal, walked up to me and said, "Do you mind if I talk to you?" I had no idea what she was going to say but told her by all means to speak freely. "Look," she said, "you have a very interesting course but you're too formal," and she proceeded to advise me to arrange the chairs in the room in a semi-circle so that the twenty-five or thirty class members could see each other. Also she told me to call the students by their first names. "And don't stand up when you lecture." It was all priceless advice for a callow American instructor and I never forgot it.

During Karchmer's tenure one of the instructors was Henry Kreisel, a respected Canadian writer and professor at the University of Alberta. The distinguished Canadian journalist, Wilfred Eggleston, joined the team in 1959 and began a program of journalism and fiction writing. Eggleston and Karchmer were regulars in the Summer Program through 1966, when Harry J. Boyle, later to become head of the CBC, took Karchmer's place. With the advent of television, the Playwriting Program expanded and was taken over by Esse Ljungh, author of some of Canada's most successful radio and television dramas.

By the time of Donald Cameron's retirement in 1969, the Eggleston-Boyle-Ljungh team had been a regular feature at Banff for many years. They identified strongly with the Senator, and when he retired, they decided that the time had come for them to leave also. Karchmer returned to Banff, and in the next few years brought in writer Jack Ludwig and poet Al Purdy to teach. In 1974 playwright and co-founder of the Manitoba Theatre Centre, Tom Hendry, created a workshop for playwrights that became a regular program. Sharon Pollock, whose plays are frequently performed in theatres and on television and radio, succeeded Hendry as head of the workshop in 1977.

Playwriting and writing became separate departments, and several experiments with different formats for the Writing Program were tried. In 1974, the School turned to Merna Hirtle's "good friend," now one of Canada's best-loved literary artists, W.O. Mitchell, and asked him to head the Writing Program.

Mitchell had a natural antipathy to creative-writing programs as they were taught in most universities. He firmly believed that the scholarly approach, with its emphasis on grades and assignments, stifled the creative process. The way to learn to write was to write without the pressure of performance being brought to bear on the novice. His approach to writing he called "Mitchell's Messy Method," which was later given the name "free-fall" by one of his students. In Mitchell's own words:

The Banff School of Fine Arts Creative Writing Workshop might better be listed as: how to find in the dark all by yourself. . . . A writing workshop, through an objective experienced mentor and other learning writers, can supply caring and honest attention from listeners who can be trusted. More importantly, by examining the findings of others, the writer learns to dilute his own darkness. In time, without the workshop support, he will find his own company in the dark; the longer he writes, the more he develops the critical alter-self to turn on his own light so that he can look objectively at the shots he made in the dark.

Mitchell's folksy manner hid a razor-sharp mind. He pinched snuff and bitched constantly about the cafeteria food, but he inspired the students to write better prose than they would have believed possible. He was a consummate actor, and his one-man shows (they were billed as "readings," but they were really performances) packed the Banff School's theatres each year.

An early Playwrights' Workshop in session, 1975. Program head Tom Hendry (l.) converses with director Douglas Riske. Founded by Hendry, later headed by Sharon Pollock and Fran Gebhart, this imaginative program helped many Canadian playwrights develop and polish scripts.

W.O. Mitchell in session. Instructor Richard Lemm is at right.

(Left) Sylvan Karchmer and student, 1973.

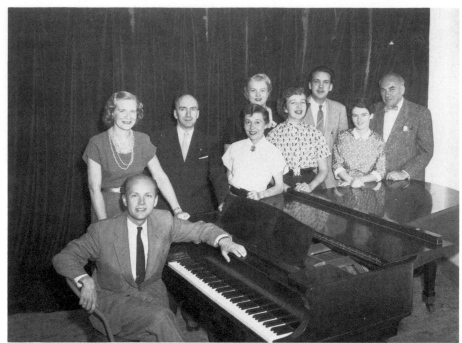

The Music Faculty of 1956 included Randolph Hokanson and Dorothy Swetnam, piano; Clayton Hare, strings; Dorothy Cadzow, composition; Sandra Munn and Marilyn Perkins, accompanists for the singing department of Eileen Higgin, Richard Eaton and Ernesto Vinci standing in the rear.

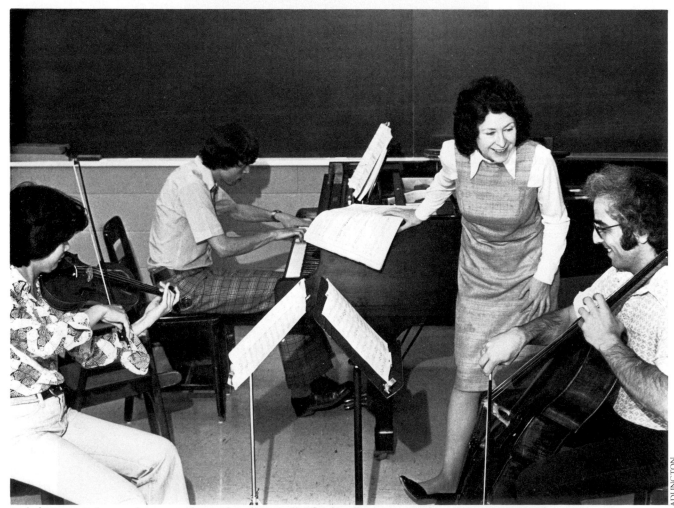

Isobel Moore Rolston, advisor, teacher and performer. Her husband Tom heads music programs at Banff.

membered at Banff. Not a narrow pedagogue, he was a cultured and civilized man who inspired a deep love of the arts among his students. His belief in the Banff School was such that he bequeathed a major portion of his estate to the Scholarship Program. Two of his early students, Gwen Beamish MacMillan and Willard Schultz, were to become his close associates, admirers, and supporters for more than ten years, and after his death, they assumed leadership of the Piano Program. In 1975, they originated the imaginative Program for Gifted Youth, which focused on younger students, while Jablonski and Gyorgy Sebok took over master-class instruction.

Sebok's arrival restored the Hungarian connection that had been established twenty years earlier by Béla Boszormenyi-Nagy, and it coincided with a flood of his countrymen into the Strings Program. A slight, debonair, and precise man, Sebok was seldom without a cigarette holder. He was a performer of great power and brilliance, but in person he was soft-spoken, with a wry sense of humour. A gifted teacher, his international reputation attracted talented young keyboard students in great numbers.

When the Banff School began its first Winter Cycle Music Program in September 1979, Isobel Moore Rolston, a former pupil of Max Pirani, was appointed the full-time Head of keyboard studies. A chamber-music specialist, Isobel so impressed the School's world-famous violinist-in-residence, Zoltan Szekely, that he would play with no one else. Her lilting Scottish burr frequently soothed the more heated debates in rehearsal among Szekely and his fellow Hungarian musicians.

In 1979, Isobel helped bring to Banff one of the world's most distinguished chamber-music pianists, diminutive, bouncy Menahem Pressler of the Beaux Arts Trio. Pressler loved Banff, and soon became a regular instructor in both Summer and Winter Programs. Elyakim Taussig and Anton Kuerti, Toronto-based piano virtuosos, were also frequent visitors.

Swiss-born Boris Roubakine, distinguished teacher and performer at Banff from 1957 to 1974.

The teaching of piano at Banff has progressed steadily since those first classes of Viggo Kihl's in 1935. Several generations of keyboard artists have come and been inspired to develop their talents as performers, teachers, and music lovers. Among them is the slim, intense, but now mature Marek Jablonski, who returns each year to teach at the School in the mountains where he was first able to share his lonely gift.

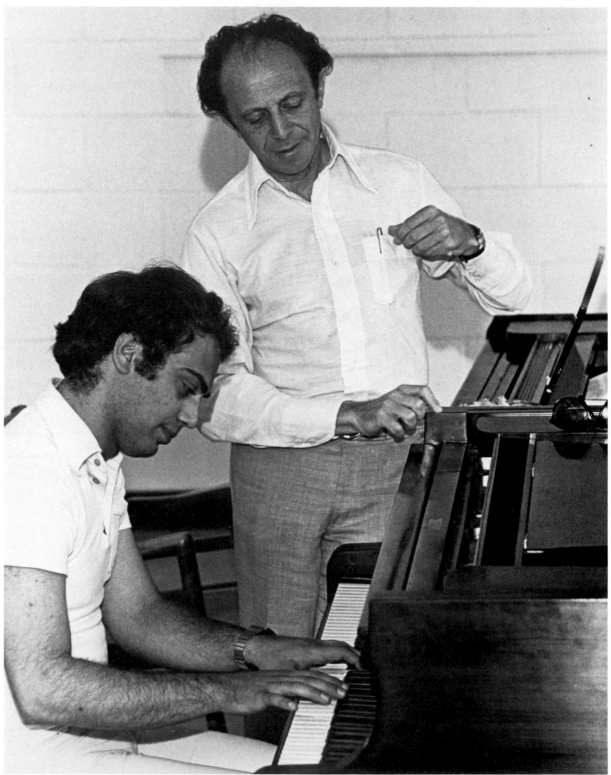

The renowned pianist and teacher Gyorgy Sebok, from the University of Indiana, has taught master classes both summer and winter since 1975.

9

The Fathers of Confederation

On a beautiful fall day in 1971, a distinguished group of Canadian artists gathered their chairs in a circle on the patio of my home in Banff. It was clear and sunny and the mountains loomed around us; the air had a quality of breathtaking, crystal purity. The group laughingly dubbed themselves "The Fathers of Confederation," for they were there to chart the future of the Banff School's Painting Program.

Although they knew each other by reputation, many had never met before. Among the "Fathers" were the late William Townsend, from the Slade School of Art in Britain and a long-time summer faculty member; painter Gordon Smith from Vancouver; Yves Gaucher, distinguished French-Canadian painter; Tony Urquhart, then just leaving the University of Western Ontario for Waterloo University; David Silcox, Associate Dean of the Fine Arts Faculty at York University; Victor Brosz, ceramic artist from the University of Calgary; Gary Lee-Nova, Vancouver avant-garde artist; and Norbert Vesak, choreographer, dancer, and Renaissance man. I had recently been appointed Director of the Banff School and took the chair for the meeting.

The discussion was lively, to say the least. I began by asking the group to tell me what was wrong with the Painting Program at the School. And they told me, in no uncertain terms. For one thing, it was over-extended. Enrolment in drawing and painting had topped 300 students in 1970, about one-quarter of the total Summer School enrolment. Classes were too large, some with as many as fifty students per instructor. Facilities were simply inadequate, consisting of a group of converted winter classrooms without any of the normal studio amenities. Not surprisingly, standards had dropped. As one of the group on the patio so bluntly said, "Few self-respecting artists in this country would come here to teach anymore." It was a devastating indictment

and perhaps exaggerated, but it had the ring of truth.

The situation was a far cry from the golden years of the 1930s and 1940s, when A.C. Leighton and his successor, H.G. Glyde, attracted an impressive faculty that included such noted Canadian painters as André Bieler (from Queen's University,) Walter J. Phillips, Charles Comfort, George Pepper, and, of course, the doyen of the Group of Seven, A.Y. Jackson. This quality was maintained during the 1950s, when Glyde and Phillips formed the backbone of a team that included William Townsend, Charles Stegeman, Francoise André, Janet Middleton, J.W.G. Macdonald, Murray MacDonald, and Harry Wohlfarth. But by 1970, something had gone awry.

One of the problems was that the art world had moved away from representational art, and particularly landscape painting, which had been the traditional core of the Banff School's teaching strength. Abstract Expressionism and Colour Field had taken over, and a group of young Regina painters were creating an exciting new vision of art at a remote northern Saskatchewan camp called Emma Lake. Barnett Newman became their catalyst, and in 1962 noted New York critic Clement Greenberg "discovered" Emma Lake and brought it international attention. Banff came to be regarded as a cultural backwater in the new wave of modern art.

Will Townsend, a British painter who had made a specialty of writing and speaking on the Canadian art scene, was the bridge between the "Fathers" and the old regime. Townsend had first come to Banff in 1951, at the time of Glyde, Phillips, and Jock Macdonald. He had returned many times and, since Glyde's retirement in 1967, was the senior member of the Painting Faculty. A remarkably handsome man, he was a familiar sight on campus with his snowy-white hair, clipped moustache, and blue turtleneck sweaters. He was widely respected by both faculty and students. On that fall day on my patio,

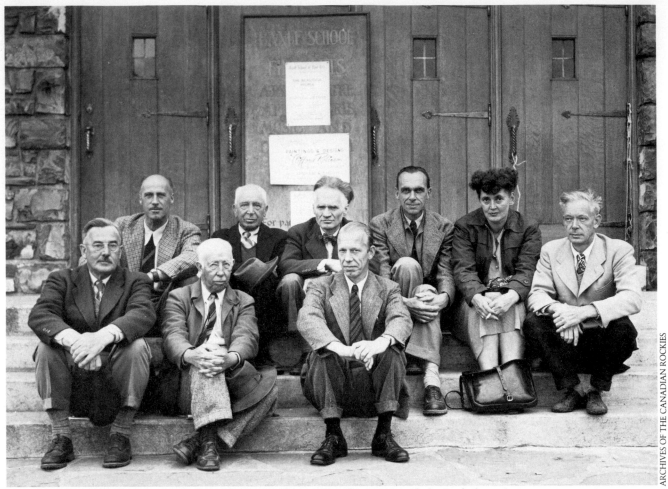

The Painting Faculty, 1947. Front (l. to r.): Walter Phillips, A.Y. Jackson, H.G. Glyde. Back (l. to r.): George Pepper, James Ditchmont, André Bieler, Murray MacDonald, Marion Nicholl, J.W.G. Macdonald.

André Bieler's painting class, 1947.

"A. Y." in the field, 1946.

Heading out for a day's painting, 1946.

67

he was critical but positive, as he spoke quietly and knowledgeably about the decline in Banff's painting reputation.

The solutions proposed by the group were drastic: cut class size, restrict enrolment, upgrade standards, rotate faculty, provide better facilities, and increase scholarship money. These were costly proposals, but I agreed to find the money somewhere. The most important recommendation was that the program be headed by a graduate of the Banff School, a prominent Canadian artist just returned from New York, Takao Tanabe. Will Townsend had known Tanabe since his early student days in Banff and strongly supported his appointment.

Gordon Smith had agreed to head the program until Tanabe could take over. Townsend committed himself to helping restore Banff's visual-arts fortunes, and he returned in 1971 and 1972, in the years of Smith's tenure. He returned again in 1973, but shortly after arriving he suffered a massive coronary and died in the Mineral Springs Hospital. His colleagues held a memorial service for him in Will's favourite glade on the campus, and his ashes were later scattered on the mountains he had come to love.

The man who inherited Townsend's mantle, Tak Tanabe, had been a teenager in Prince Rupert during the Second World War, and his family were among those Japanese-Canadians who were interned and relocated to camps in the interior. The experience left a scar on Tanabe. Often brusque in manner, his stern exterior hid a warm and playful personality that softened his outspoken opinions on artistic matters.

He first came to Banff in 1950, "just travelling through." Also in Banff that summer was another west-coast native who was Tak's life-long friend, Joe Plaskett. To earn money for his studies, Tanabe did odd jobs around the School, serving as janitor and handyman. Tak remembers reporting to the Senator first thing every morning for instructions on his day's work.

After leaving Banff, his career blossomed in Vancouver and New York. Almost two decades passed before he returned to Banff in 1973 as full-time artist-in-residence and Head of the Painting Division. His charge was to upgrade the Summer School and to lay the groundwork for a year-round Painting Program on a small and selective scale.

He set to with a vengeance. His next summer's faculty included Smith, Townsend, Glyde, Stegeman and André, Roy Kiyooka, Ivan Eyre, and Claude Breeze, some of the mainstream Canadian artists of the day. The next year, Tanabe introduced conceptual artist Iain Baxter to Banff.

During his tenure, Tanabe's list of summer faculty members was indeed impressive: David Bolduc, Joe Plaskett, Jack Chambers, Ted Godwin, Dorothy Knowles, Marcelle Ferron, Judith Lodge, Tony Urquhart, Dennis Burton, Graham Coughtry, Douglas Morton, and a host of others, came for varying lengths of time to share their knowledge and experience with the Visual Arts students.

Tanabe had a firm rule – no more than two consecutive years on the summer faculty for anyone, regardless of his or her distinction. This was an attempt to avoid stagnation, and it brought vigour and excitement to the Painting Program at Banff. A system of screening applicants was instituted and the number of students admitted to the courses was reduced. In a short space of time, Tanabe revitalized the Division and turned it around to face the modern world of art.

Glyde Hall, opened in 1976, provided first-class studio space for the first time. Instructor Norman Yates at right.

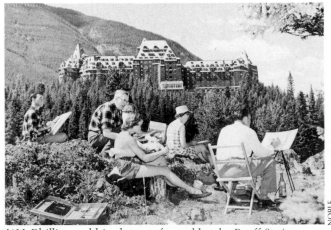

W.J. Phillips and his class are framed by the Banff Springs Hotel, 1952.

William Townsend with student, 1952.

Sheila Piercey and Ron Nelsen appeared as Violetta and Germont in La Traviata, *1961.*

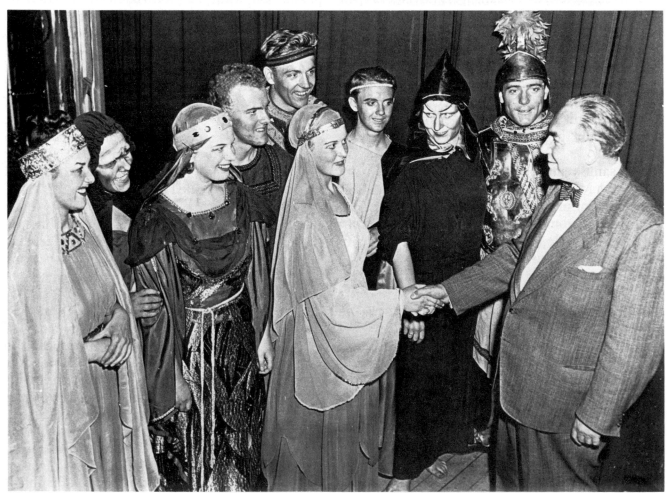

The cast of Dido and Aeneas *with Ernesto Vinci,1952.*

ing the 1951 session. Vinci recalled:

> With our first venture, Purcell's *Dido and Aeneas*, he [Cameron] enjoyed bringing into co-operation opera, drama, ballet, and orchestra divisions. His enthusiastic reaction to this new effort was most gratifying and stimulating to all concerned. Singers being, of course, a temperamental lot, I admired his tolerance and patience, together with his sense of sometimes quite sarcastic humour when divas vanished or a male star had to be rescued from the beer parlour in town.

With Vinci there came a stream of young talent from Toronto, most notably from the University of Toronto's Opera Training School. Banff became a summer production centre for students of that school, as well as for some of its graduates, who were brought in to play lead roles. Andrew MacMillan, a handsome bass-baritone, was Production Assistant in the Department for several years until his untimely death. James Craig later joined as Musical Director and operatic coach, his wife Constance Fisher as performer and Production Assistant, and Jean Munro Stensson and George Brough as accompanists. Brough conducted the opera orchestra.

Alexander Gray, a noted baritone who now heads Banff's Summer Opera Program, first came in 1957. He had been studying in Toronto with Vinci, and he was to play a lead role in the two operas being produced at Banff that year: *Gianni Schicchi* and *The Old Maid and the Thief*. Also lured from Toronto were Bernard Turgeon, Sheila Piercey, Victor Braun, and John Arab, a tenor originally from Halifax. All were Vinci students, and by a strange twist both Turgeon and Gray would later succeed Vinci at the School.

Most of the young singers from Toronto were already professionals when they arrived. They came on full scholarships and were cast in leading roles. Despite their professional status, they worked hard – vocal master classes in the morning, and choral study and rehearsals until nearly eleven o'clock each night. Gray remembers it fondly as a great experience, performing major roles that he could not otherwise have expected at that age.

Full-scale opera productions featuring young professionals and students became a regular part of the Summer Program at Banff. At the end of the season, these productions toured the province, visiting Edmonton, Red Deer, Calgary, and Lethbridge. The singers and musicians were billeted in private homes or at university residences.

"It was a wonderful thing, to be able to tour with what we had done here," said Gray. "To us, that was just as important, if not more so, than coming to the School. We would perform twice in Banff and then do five extra shows on the road, which gave us the experience of working as part of a touring company."

In 1958, the opera production was Rossini's *Barber of Seville*. Gray and Arab had returned in lead roles, but the show was stolen by a lanky, rubber-faced comedian by the name of James Beer who sang the part of Don Basilio, and who is now chorus master for the Southern Alberta Opera. That same year, Elgar Higgin sent a promising young tenor from Edmonton to act as understudy to John Arab. His name was Ernest Atkinson, and he had never been on stage before. He recalled: "To have to do something like that was a real thrill. ... I just fell in love with opera. I was working for Shell Oil at the time, and I was going into engineering. But after that summer in Banff, I was smitten. I packed in the oil career."

Atkinson went to Toronto to study with Vinci. There he met an attractive young piano student who was meeting the expense of her studies by accompanying Vinci's students. They were married soon after, and Sandra and Ernie Atkinson returned to Banff often in later years. Ernie remembers singing in one particularly memorable production of *Falstaff* in 1964. In the cast with him were such notable stars as Bernard Turgeon, Lillian Sukis, Marvene Cox, Constance Fisher, and Allan Monk, and the conductor was James Craig.

Monk was another Higgin protégé, a Calgary boy with a lovely baritone voice. When he first came to Banff, his strong voice was overshadowed by a wooden acting style. This did not remain a problem for long: he later appeared in San Francisco and at the Metropolitan Opera, where reviewers commented on his strong stage presence.

Throughout these years, Vinci and Cameron forged a very close personal link. Cameron was particularly proud of the opera, and he would make a point of driving around to see the various touring productions for himself, regardless of the distances.

Following his retirement in 1968, Vinci was presented with an honorary degree from the University of Calgary at a special convocation held in Banff. At the same convocation, Cameron's retirement was announced. Their partnership continues, however: the names Cameron and Vinci now adorn two of the early buildings in the core of the Banff campus.

One of Vinci's protégés, Jim Craig, ran the Opera

Martial Singher gives a master class with the help of Marie-Therese Paquin at the piano. The student soprano is Marilyn Zweifel.

Mozart's **Cosi Fan Tutte**, 1969 starred John Duykers, Dodi Protero and Ernest Atkinson.

(Right) Alexander Gray and Nancy Gottschalk, Robert (Roy) Glover and James Beer played major roles in L'elisir d'Amore, 1965.

74

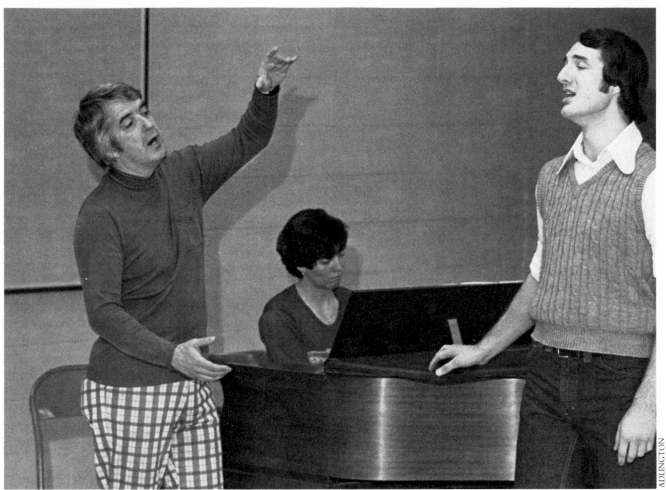

Bernard Turgeon headed the Opera Division from 1972 to 1978.

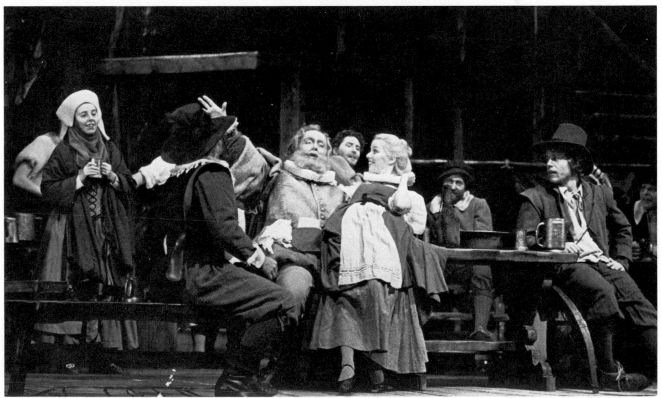

Robert Grenier as Falstaff in the 1980 production The Merry Wives of Windsor.

Department for two years after Vinci's departure. He was followed in 1971 by Bernard Turgeon, who had been a student at Banff in the fifties and had since had a distinguished career on the stage and television. With Turgeon came many innovations. The noted husband-and-wife team of Leopold Simoneau and Pierrette Alarie came for several years, while James Lucas, Carlo Maestrini, and Helmuth Froschauer were brought in to direct.

Turgeon also began an Academy of Singing, a six-week program held early in the summer for senior singers, and a distinguished faculty was recruited. Among its members were Martin Isepp, Martial Singher, Rose Bampton, Herta Glaz, David Astor, Jean Letourneau, and Marie-Thérèse Paquin, the Grande Dame of opera in Montreal, who came to Banff as operatic coach and accompanist.

Paquin emerged as a strong personality at the School, and remained one of its greatest advocates over the next decade. Ernie Atkinson said that her addition to Banff was like "a shot in the arm. She wasn't a young lady, but she walked in with all the fire and enthusiasm of a youngster, and shamed a lot of the younger faculty." Her birthday party on July fourth each year became a tradition in the School's dining room.

In 1978, Turgeon stepped down as Head of Opera and handed the reins to Alexander Gray, who continued the same program that Turgeon had established. Assisted administratively by George Ross, Gray scored a coup in 1979 and 1980 when he brought in such respected artists as Leon Major, Walter Ducloux, and Boris Goldovsky to enrich his summer teaching faculty. The Opera Program that had started so modestly in 1949 with Vinci and Eaton had hit the big time.

In 1981, the Opera Program was moved into the early summer period in order to lessen the load on production crews and facilities at the theatres. The first opera to be mounted under this arrangement was Britten's *Albert Herring*, directed by Douglas Campbell and conducted by Roderick Brydon. Critics agreed it was one of the School's finest productions.

Perhaps one of the most enduring memories of those who have visited the Banff School in summer is the sound of opera students practising, their full, rich voices carrying out over the lawns and down into the valley. And their gifts are further appreciated on Sundays, when they join in the services of several Banff churches. Now, with the addition of a Winter Program in Music Theatre, their delightful and enriching presence is felt year round.

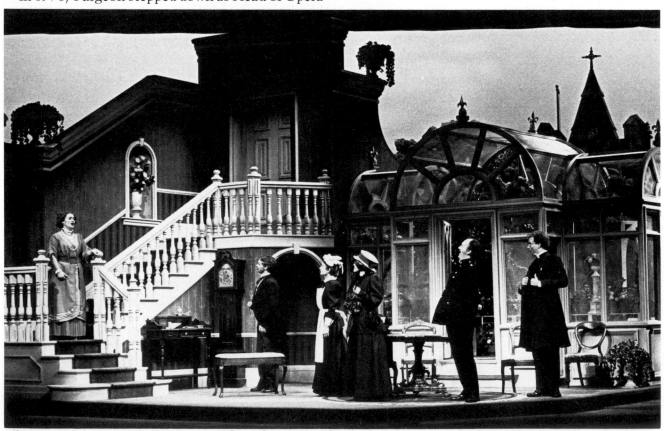

Albert Herring by Benjamin Britten was performed in 1981 under the direction of Douglas Campbell. Brian Jackson designed the outstanding set.

11
The Territorial Imperative

Each year at the beginning of the summer session, the Banff Centre faculty gather for a discussion of plans for the season ahead. And each year from 1949 on, Donald Cameron would make a gently mocking speech at these meetings about the territorial claims of the Ballet Division, concluding with a firm rejection of their request for more space. His eyes twinkled as he looked directly across the room at an attractive, white-haired woman, whose blue eyes twinkled right back.

The woman was Gweneth Lloyd, founder and head of the Royal Winnipeg Ballet, and for twenty years the leader of Banff's Dance Program. Few, if any, individuals have had as much influence on the development of dance and dancers in Canada, and Banff played an important part in the ultimate success of her work.

They were two of a kind, Donald and Gweneth. Maybe it was because they both had impossible dreams. But they shared an admiration and respect that never diminished in the years to follow. And despite Donald's annual speeches, Gweneth usually got what she wanted for her dancers – eventually.

Gweneth and her partner, Betty Farrally, had come from England in 1938 to start a ballet school in Winnipeg. From their modest beginnings grew one of the world's leading dance companies, the Royal Winnipeg Ballet. At the beginning, their dream was just as impossible as Donald Cameron's dream of a world-class school of arts in the mountains. But they persisted and from their young dance school Gweneth and Betty began to mount productions. Gweneth choreographed, and Betty danced, coached and taught.

Betty Farrally (l), Brian Macdonald and Gweneth Lloyd. Banff. 1960. ARCHIVES OF THE CANADIAN ROCKIES

They enlisted the help of Lady Tupper, and the grain-merchant Richardson clan of Winnipeg, who continue to support ballet in Winnipeg to this day.

As their productions became more elaborate, they enlisted more talent, until the day in 1951 when they performed before Her Royal Highness, the Princess Elizabeth. A royal charter followed in 1953. The little Winnipeg company was mounting full ballet productions in Canada years before the National Ballet of Canada appeared on the scene in Toronto in 1948. Although she admires what the National Ballet has done, Gweneth still bristles at the presumption of the "national" title and at the frequent myopia of easterners who think that dance in Canada was born in Toronto.

In 1941, Gweneth had written to Donald Cameron suggesting that a Ballet Division be started at his fine arts school. It was war-time, funds and facilities were limited, and he wasn't able to say yes. But he didn't forget the suggestion, and in 1946,

Gweneth and a representative of the Royal Academy of Dancing in England visited Banff at his request to observe what was then being done in movement and eurythmics.

In 1947, the Banff School of Fine Arts calendar stated: "After an absence of some years, courses in ballet are being reintroduced in the Banff School as non-credit courses in the Drama Division. Basic technique of the ballet on the system of the Royal Academy of Dancing." A young dancer named Joan Sterling was listed in the calendar as a member of the Theatre Division staff, and as the dance instructor for that year. Gweneth had been unable to come, and in fact did not begin teaching in Banff until 1949, succeeding Jean McKenzie, one of her leading Winnipeg dancers.

Betty Farrally joined Gweneth in Banff the next year, and the two remained as mainstays of the Ballet Department until Gweneth's retirement in 1967. Betty remained as co-head of the Division until 1981.

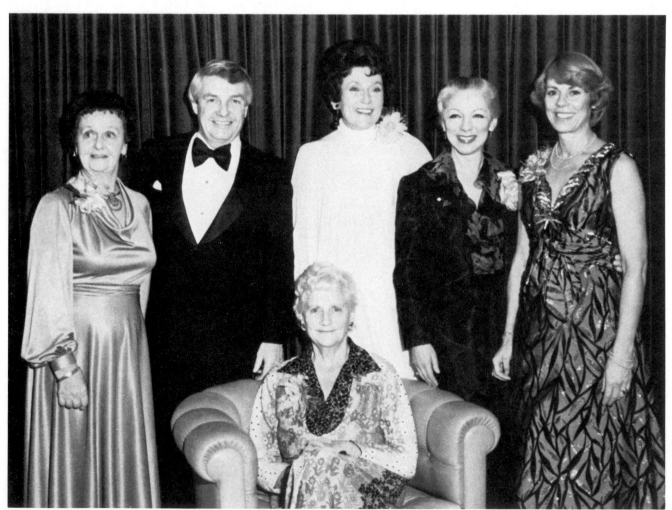

The "Founding Ladies" of dance in Canada, with Premier and Mrs. Lougheed, 1982. Seated: Gweneth Lloyd. Standing (l. to r.): Betty Farrally, Premier Lougheed, Ludmilla Chiariff, Celia Franca, Jeanne Lougheed. Mrs. Lougheed was herself a former Banff student.

Banff's Summer School was an inspirational experience for many young dancers. Richard Cragun, shown in Gweneth Lloyd's 1961 production of **Arabesque**, became one of the world's leading dancers with the Stuttgart Ballet. Jennifer Penney, third from left, is prima ballerina with Britain's Royal Ballet.

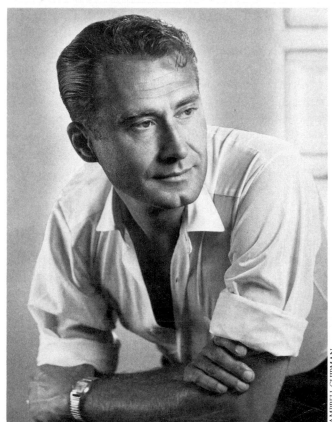

Arnold Spohr, of the Royal Winnipeg Ballet, and co-head of the Ballet Division at Banff for many years.

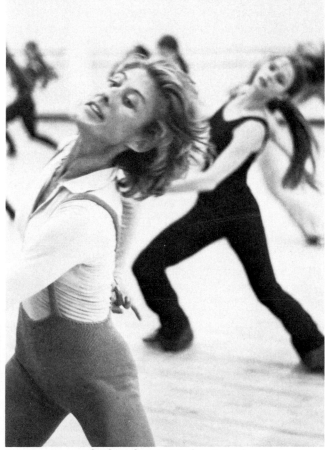

Eva von Gencsy leads a class in Modern Jazz dancing.

Gweneth looked like everyone's idea of an English mum. She was a handsome woman, dignified, white-haired, with lipstick that was always slightly askew. Betty, small and pixie-like, was the perfect foil, her sense of humour defusing a thousand crises every summer.

Gweneth remembers that first year: "I had a class of ten students – all at different stages – and we had our classes in the basement of one of the public schools. It was one of those unusual summers, with rain, sleet and occasional snow, and I taught in a coat, gloves and a scarf, and as the floor was cement, most of us finished the course with strained Achilles tendons."

Despite the Dance Program's inauspicious debut, its establishment marked the beginning of a Platonic love affair between Gweneth and Donald. Gweneth had instantly admired Cameron and his big ideas; they were similar to her own. The two personalities were alike in many ways – both were tough, ambitious, with a touch of charm or ruthlessness, whichever was required. They always kept their goals clearly in mind, and they allowed nothing to get in the way.

"The battle for space went on as enrolment grew, but the man with the twinkle in his eye [Cameron] always did as much as he could and more – terrifying in his rage, dour as his Scottish ancestors in his displeasure, no one could be more outgoing and appreciative as he was on the 'good' days," said Gweneth.

The Banff Summer School became a kind of "farm team" for the Royal Winnipeg Ballet, a role that Cameron understood fully and supported. He approved of the professional connection and orientation to the training at Banff. Gweneth and Betty were his ideal agents, and in no other department was there such a close identity of interest and mutual respect.

For the first ten years, dance instruction was offered as part of the Drama and Theatre Division of the School. Although there were other instructors from time to time, Gweneth and Betty were the two regulars. In 1958, ballet finally became a separate department, and its growth really dated from that year.

Gweneth initiated the practice of inviting guest instructors from the Royal Academy of Dancing each year, in the conviction that the Academy's system of training for young dancers established recognized standards and eliminated the haphazard approach that had existed before its introduction. Later, after Gweneth's retirement from the School,

Betty and her colleague, Arnold Spohr, decided to alternate the RAD instructors with outstanding ballet teachers from other parts of the world, a policy that led to contacts with such notables as Vera Volkova and Annette Amand of the Royal Danish, Maria Fay from London, Natalia Zolotova from the Bolshoi, and Zolotova's husband, Boris Rakhmanin.

After 1958, the faculty grew with the addition of Dorothy Gatird, who for more than twenty years has remained a ballet accompanist. In 1959, an English dancer named Sonia Chamberlain came for the first time and returned for thirteen successive summers. And in 1961, a tall, lanky dancer-choreographer named Brian Macdonald joined the teaching team, introducing jazz ballet. In 1964 he founded the Musical Theatre Program.

Thereafter, the teaching of jazz dancing was conducted by a lithe Hungarian charmer named Eva von Gencsy, a refugee who had fled her native country after the war and settled in Winnipeg, where she worked as a domestic servant and doubled as leading dancer for the Royal Winnipeg Company. Clarence Shepard, Q.C., in whose home Eva worked, described her dazzling his guests before dinner, then departing for rehearsal, leaving the Shepards to cope with the service and the dishes. Eva was later to found an innovative dance company in Montreal called Les Ballets Jazz, and from 1963 onward she came regularly to Banff during the summers.

Her ballets were always immensely popular and were frequently used as the finale to the annual Festival Ballet Program. In 1971, the closing number was called *Born to Dance*, a campy presentation starring Eva herself, and performed to the accompaniment of flashing strobe lights that made the whole thing look like something out of an early Keystone Kops comedy. It was a brilliant number and a great success on opening night. The next night, a curious child reached over the orchestra pit at intermission and fiddled with the strobe lights. They failed to flash at the critical moment, just as the group came dancing onto the stage. Eva had to do her entire number without the benefit of lights, and much of the effect was lost. She was furious – she would not appear for curtain calls, and stamped off to the Banff Springs Hotel where she took three days to simmer down. But simmer down she did, and she was back again the next year with another spectacular success.

Reid Anderson, once a student at Banff, returned in 1982 as instructor after a brilliant international career.

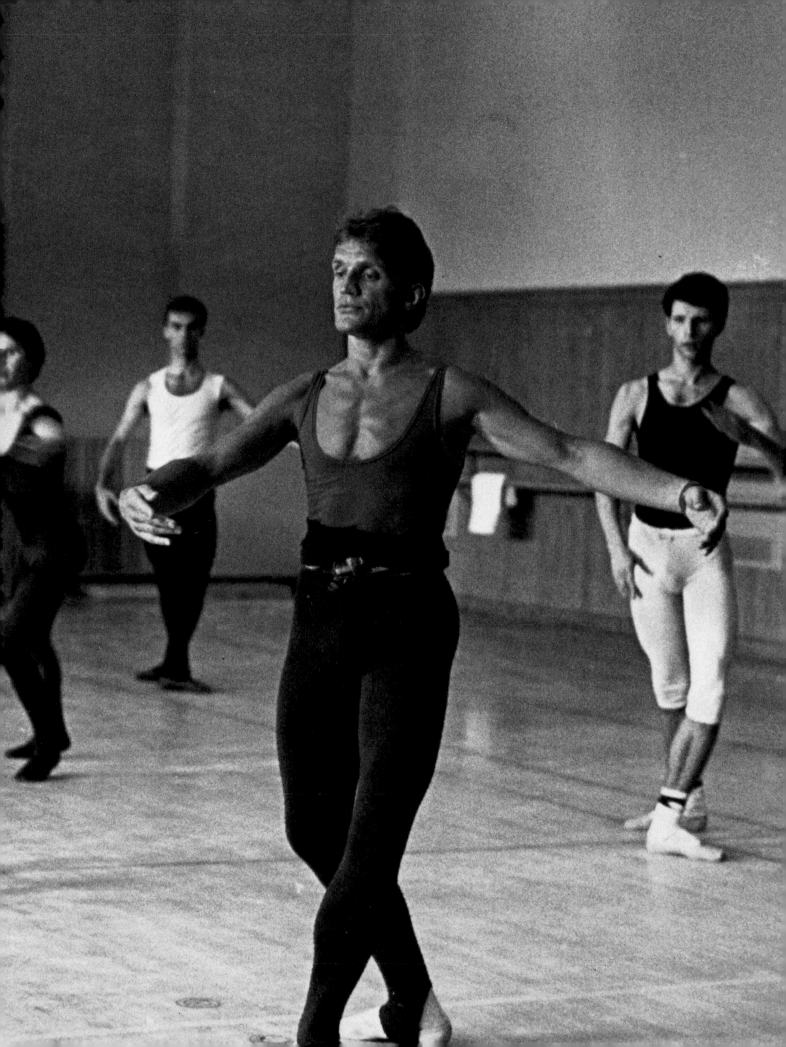

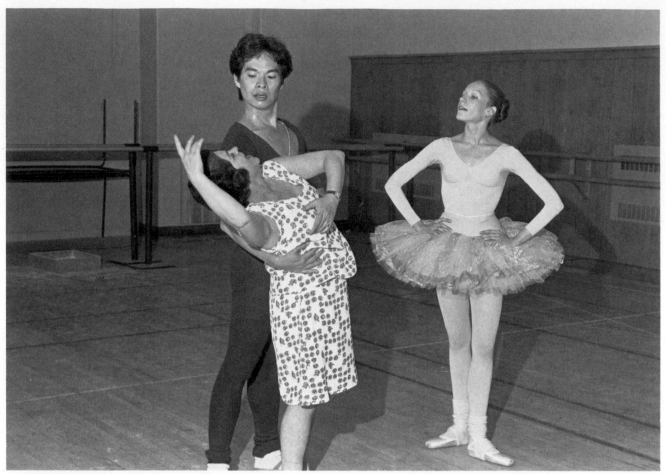

Natalia Zolotova of the Bolshoi instructs Roger Shim and Evelyn Hart how to do a pas de deux.

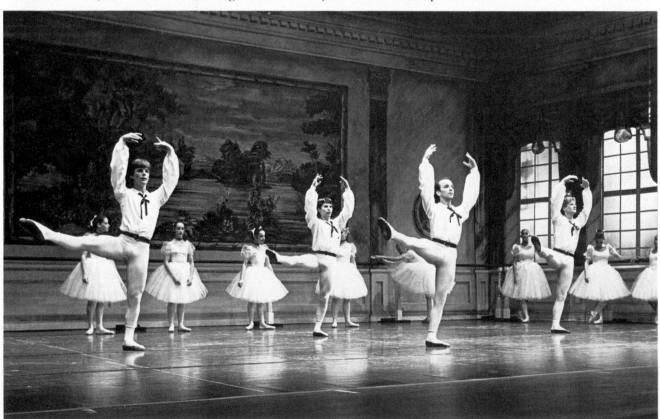

The 1982 Festival production of Bournonville's Konservatoriet, *staged by Annette Amand with set by Laszlo Funtek.*

Although jazz ballet had been introduced, Banff's teaching approach was still based on the discipline of classical ballet. Classes were occasionally given in modern dance, character, and other aspects of the art, but the backbone was always ballet, particularly as espoused by the Royal Academy of Dancing. By 1967, when Gweneth retired, there were more than 200 students, mostly female, in the Ballet Division, and the campus swarmed for six weeks with slim young girls, their hair tightly pulled back in traditional buns, wearing multi-coloured leotards and hideous woollen warm-up stockings.

The ballet presentations became a highlight of Banff's Summer Programs. Often, they provided an opportunity to try out some of Gweneth's Winnipeg choreography, which would ultimately find its way into the Royal Winnipeg Ballet repertoire. Banff was a natural place for a talented young choreographer like Brian Macdonald to premiere some of his stunningly original works. The productions grew increasingly lavish, and workshops were set up to allow the less-developed dancers to appear on the public stage. Performance and preparation for performance were always an important part of education at Banff.

Although the Banff School was tied closely to the Winnipeg company, other companies around the world benefited from the program. One student, Richard Cragun, went on to star on the world's stage as lead dancer with the famed Stuttgart Ballet. Jennifer Penney later joined the Royal Ballet and is now their prima ballerina. Virginia Wakelyn, a Banff native, also went on to the Royal Ballet, and a lanky girl named Evelyn Hart starred in the 1977 Summer Festival, then became the Royal Winnipeg's leading dancer and winner of the prestigious Varna Gold Medal.

Reid Anderson, now a leading dancer with Cragun at the Stuttgart Ballet and a summer faculty member in Banff, first came to Banff at the age of thirteen in 1962. He subsequently spent four summers there: "Those precious weeks at Banff provided me with a basis from which I've built my professional career.... Banff was the first time that I studied ballet every day over an extended period of time. This was my first exposure as to what life as a ballet dancer might one day be like and I thrived on it. The Banff experience fed my hunger for ballet like no other."

Reid recalls that first summer watching Brian Macdonald choreographing his now-famous ballet, *Aimez-Vous Bach?*: "I saw how rehearsals with a choreographer progressed as his mental images took on physical form. I was enthralled. ... Banff nurtured and inspired me. I remember each year, as spring was nearing its end, that itchy feeling of longing for Banff overtaking me again."

After his last summer as a student at Banff, Reid went to the Royal Ballet School where he soon became an understudy. Despite his youth, he was prepared for the challenge.

I wasn't nonplussed at all! Everything I encountered was familiar to me because I had already experienced it in Banff. I had good training and discipline; I learned extremely quickly because we had to in Banff; I was at home in rehearsal; I knew how to understudy and, most of all, I could produce the goods when I was suddenly thrown into something. The Banff experience was my ace in the hole, my trump card, that special invaluable education that most other students didn't have. It also stood me in good stead when I joined the Stuttgart Ballet in 1969. I got ahead because I learned quickly, worked hard and knew how to work with a choreographer. I was a favourite with John Cranko and have since created ballets with Kenneth MacMillan, Glen Tetley, John Neumeier, Jiri Kylian, and William Forsythe. Who would have thought that all those years ago in Banff I was being prepared to work with some of the greatest choreographers in the world?

When Gweneth and Betty decided to leave Winnipeg and move to Kelowna, where they set up a new school, Arnold Spohr took over the direction of the Royal Winnipeg Ballet. Spohr made a point of coming to Banff each summer to "set" the Festival ballet productions and to look over the talent that was performing there. He, too, saw Banff as a valuable source of young dancers with potential. At one time, better than half of the Royal Winnipeg company had been students at the Banff Summer School.

For a period of eleven years, the School instituted a novel experiment that combined the disciplined artistry of ballet with the distinctly Canadian sport of figure skating. In 1961, Osborne Colson, then Director of figure skating at Leaside Memorial and Varsity arenas in Toronto, approached Cameron with the idea of starting a figure skating school that would have a different approach: it would treat skating as an art form, not strictly as a sport, as it had been regarded up to that time.

Colson himself had been a prominent skater, a Canadian gold medalist, and for seven seasons a

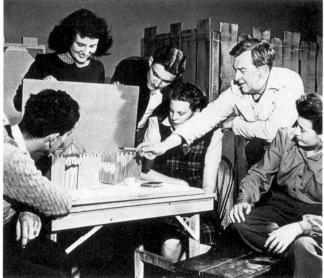

Burton James instructs stagecraft students, 1946. The model is for the production of Gwen Pharis Ringwood's The Rainmaker.

(Left) Two visionaries of the theatre. Laszlo (Les) Funtek (l.) and famed Czech designer Josef Svoboda at a display of Svoboda designs in the Eric Harvie Theatre, 1975.

The Theatre Faculty, Les Funtek (l.) and John Graham (r.), 1962, with prize-winning students.

theatrical-designer Theodore Cohen and his brother Eliot as stage carpenter and technician. A brilliant teacher, Ted Cohen returned for five years as Elizabeth Haynes's close collaborator. After he left Edmonton and the Banff School in 1938, he went to New York, changed his name to Corday, and became well known in radio and television there.

The theatre he had to work with in Banff in those early days was rudimentary, to say the least. Bretton Hall Theatre had been built in 1883 as part of the Brett Sanitorium by Dr. R.G. Brett, later Lieutenant-Governor of Alberta. The sanitorium and theatre sat on what are now the grounds of the Parks Administration Building.

By the 1930s, the theatre – "just an old dance hall with a stage," as Elsie Park Gowan described it – had seen better days. It still had boxes and gilded cupids, and held about 250 seats, but before the shows, Ted and his boys would place logs and other supports under the floor for fear it would give way. Elsie remembers having to dress out on a verandah that had only a screen on it. "It wasn't closed in and let me tell you it was no fun when the wind howled down the valley – and all those kids in cheesecloth costumes!" Gwen Pharis Ringwood remembers best the splinters on the stage, "and the lighting was very hard to do, but there was an atmosphere about the place that was quite exciting – for one thing, the acoustics were pretty good: it was old wood, but it seemed very mellow."

When the theatre was torn down after the summer session of 1939, an aggressive campaign raised $150,000, and a new auditorium opened on Banff Avenue in January 1940, for the joint use of the Fine Arts School, the Banff School Board, and the community theatre group. It served as the main production centre for the Summer School performances until 1967, when the School acquired its own theatre.

Many memorable productions – theatre, opera, dance, and music – were to be held in the Banff Avenue auditorium. With 600 seats, it marked a step up from Bretton Hall, but it had virtually no wing space, and its small dimensions demanded a great deal of ingenuity from designers and directors. Supplies were easily obtained – crew members just walked across the street to the hardware store for nails or glue. On sunny days, flats were painted in the neighbouring vacant lot where actors also rehearsed.

Many of those early plays in the new auditorium were directed by Sidney Risk, who mounted full-

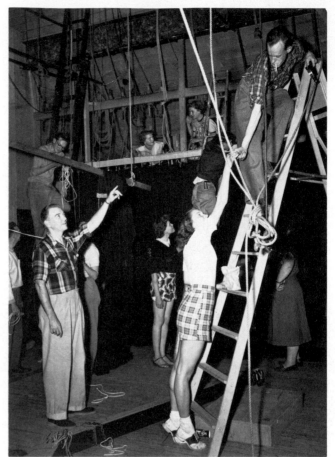

Hanging drops in the Banff Avenue Auditorium, 1952. The instructor is John Russell.

length drama productions, replacing the earlier evenings of one-act plays. In 1944, Risk was joined by Burton James, of the famed Seattle Repertory Playhouse, who taught two courses on stagecraft. James, a brilliant man with an illustrious reputation in American theatrical circles, immediately made a favourable impression. His inspiring lectures and imposing personality made him a leading figure in the summer programs during the last years of the Second World War and for seasons after.

But he had an Achilles heel. James and his wife, Florence, were known for their liberal political views, and in the early 1950s they ran afoul of the U.S. government's zealous hunt for Communists in the theatre. James had been an acquaintance of John Garfield, a famous Hollywood actor who had been accused of Communist connections and who was later blacklisted and hounded from his professional career. James was caught up in the same witch–hunt and ultimately lost his beloved Seattle theatre. He returned to Banff one more summer, a broken man. Disillusioned by events in his own country, he died

(Overleaf) Murray Laufer designed the set for The Merry Wives of Windsor, *1981 opera production.*

The 1,000 seat Eric Harvie Theatre is baptized with a ballet performance, 1967. The theatre was not finished; there were no ceilings, lights were strung on the rafters, and the audience sat on temporary chairs.

the following year. His ashes were scattered at beautiful Peyto Lake, one of his favourite areas in the Canadian Rockies. Florence settled in Saskatoon, where she continued to be active in local theatre circles.

Cohen, James, and their successors had an eclectic view of theatre. They didn't teach just the technical aspects, they taught total theatre, of which the technical production was only a part. Aspiring actors were exposed to painting sets and setting lights, and budding young backstage personnel were themselves drafted into acting roles. One of CBC producer Vincent Tovell's most vivid memories of a summer (1946) spent in Banff was the sight of a quiet, curly-haired acting student named Bruno

(Left) Artist Gordon Adaskin was a member of the design staff throughout the 1970s.

Gerussi patiently painting bamboo flats, hour after hour, for a production of *The Hasty Heart*.

Harold Baldridge, a student in 1958 and now director of the prestigious Neighbourhood Playhouse in New York City, remembers that facet of his Banff education with gratitude. In addition to acting experience, Baldridge recalls working with John Graham and Rodney Sample, who ran what was then the technical department.

We all built scenery. Most of it was built by us; and painted by us and used by us. We each got assigned a production to stage-manage, and we would go out on tour with that production. That technical training has been pure gold for me. I have not had to take a job outside the theatre since I was twenty years old. They weren't always the jobs I wanted, sometimes it was running a

The Ceramics Program was originally headed by J.B. McLellan, a prominent art teacher in his native Scotland who came to Calgary as an instructor at the Provincial Institute of Technology and Art. He taught at Banff only one year before enlisting with the RCAF in June 1942. Classes in pottery had to be cancelled and were not restored until the early 1950s.

In 1954 Sybil Laubenthal assumed responsibility for ceramics, heading the program for four years. Sybil had grown up in Germany, where she had worked in the studios of Jan Bontjes van Beek in Berlin and also in a ceramic factory in Stuttgart. She immigrated to Canada in 1952 and set up her own studio and teaching program in Edmonton. Laubenthal set a high standard for the Ceramics Department, a standard that was maintained in subsequent years when a succession of teachers took over from her, including Santo Mignosa, Roy McCowan, Steve Repa, and Priscilla Howell Theroux.

Ethel Henderson retired after the 1963 session. When she learned she was terminally ill, she came back to live in Banff where she died in 1965 in the Mineral Springs Hospital. Mary Sandin's last year in Banff was 1961. For a period of six years following, the Weaving Program was offered only every other year, with the noted Swedish teacher Malin Selander as instructor. She, in turn, was succeeded in 1969 by her countrywoman Lilly Bohlin, who remained for the succeeding four years.

In 1973, Mary Andrews, now a Master Weaver, and Mary Snyder, a respected weaving expert from Oklahoma, together took over the program. Mary Snyder moved to Banff in 1976 and established the first Winter Weaving Program that year. She resigned in 1979 to be replaced by Mariette

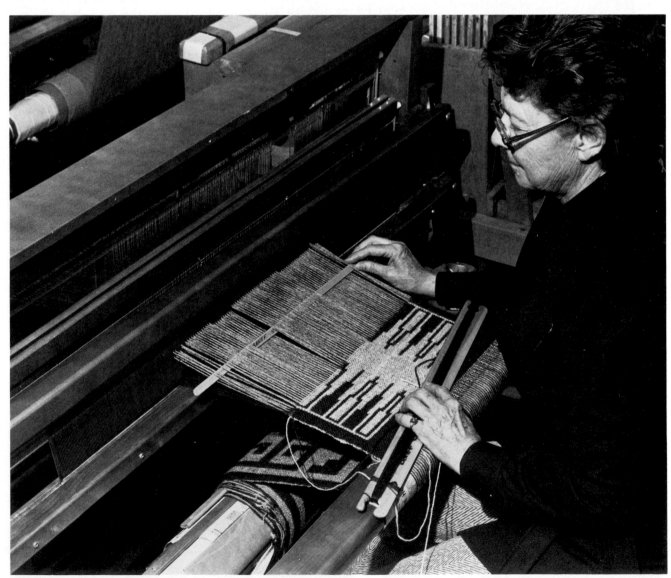

The first year-round weaving courses were begun in 1976. Mary Snyder moved to Banff and took charge of both summer and winter programs.

Rousseau-Vermette, who proceeded to nudge the Fibre Program away from traditional weaving and towards a concept of fibre as an artistic medium. She was assisted by Elsa Sreenivasam and Lynne Mauser-Bain, who have continued to be mainstays of Rousseau-Vermette's faculty.

Fibre and ceramics have always carried the stigma, with artists, of being mere "handicrafts." The Canada Council has only recently recognized them as artistic media, and in truth, they are often taught from a narrow, technical point of view. While technique provides the necessary underpinning for all art, there is a dimension beyond the mechanical, and it was that dimension that Rousseau-Vermette was intent on developing in her students.

She herself was the embodiment of the fibre artist. Quebec-born, she studied at the Ecole des Beaux-Arts there, then at the Oakland College of Arts and Crafts in California. Her work was first exhibited at the prestigious Lausanne Biennale in 1962, and at the Museum of Modern Art in 1969. She was commissioned to make the curtain that Canada gave to the John F. Kennedy Center in Washington, and she worked closely with architect Arthur Erickson in designing the ceiling for the new Roy Thomson Hall in Toronto.

Her creations are elegant in their simplicity, and colour is always a prominent feature. One author wrote, "She seeks to translate the colour of the changing seasons of Canada and the softness of distant mountains into her work." Her pieces are "more in the nature of soft murals that are massive and monumental."

The warmth of her personality, coupled with her stature as an artist, brought immediate success to her efforts to transform the Banff program. She had only to ask, and the leaders of the art world came to participate. Proud of her Québécois roots, she was a passionate Canadian: she lived and worked in the little mountain village of Ste. Adèl-en-Haut in Quebec, but she commuted frequently to another mountain village 2,500 miles to the west, to "mother" her new program there.

Within a short space of time, the program was completely transformed. Greater emphasis was put on obtaining Canadian and international students at a very high level. Many of the looms were moved out of the studio, although traditional weaving retained its place in the program. A new emphasis was added: a studio approach paralleling that of the

Elsa Sreenivasam shares her expertise in fabric surface design with Inese Birstins (l.), Francois Alacoque, Cathryn MacFarlane, Mariette Rousseau-Vermette and Kai Chan, during 1980 Interchange.

Painting Department. One of Rousseau-Vermette's most notable achievements was the institution in the summer of 1979 of the Fibre Interchange, which brought rave reviews from fibre artists around the world.

While fibre art was growing as an independent program in the Visual Arts Department, similar developments were taking place in ceramics. In 1971 the program was expanded to include a variety of instructors teaching specialized subjects. That year was the first for Leslie C. Manning, then teaching at the Allied Arts Centre in Calgary. Following the summer session, a committee of experienced professionals in the field, including Victor R. Brosz of the University of Calgary, and well-known Alberta ceramists, John A. Porter and Luke Lindoe, recommended strongly that the Centre improve its facilities, up-grade its programs, and appoint Manning as full-time Head of the Department. In 1972, Manning joined the Banff Centre and established the first Winter Studio Program in ceramics. He also took charge of summer programs.

Manning came to Banff as a young and relatively inexperienced instructor. He possessed a fabulous technique on the wheel, producing mostly traditional work of a functional nature. But he was ready for greater challenges, and he began experimenting with laminations of different clays, and with pots that were broken or asymmetrical in form. He was an excellent and devoted teacher, and his growing stature was recognized in his election as first President of the Canadian Crafts Council. His own emergence from potter to artist-in-clay closely paralleled the development of the program he headed.

From the time of his arrival in Banff, the record has been one of consistent growth and development, until today the Banff Centre's Ceramics Department ranks highly in the world. Most of the world's leading ceramists have taught in Banff at one point or other, including such notables as Ruth Duckworth of Chicago, Kurt and Gerda Spurey of Austria, Peter Voulkos of Los Angeles, Tony Hepburn from New York, and Tatsuo Shimokoa of Japan, an artist who is regarded as one of that country's "national treasures."

The Ceramics Program received added momentum in 1976 with the opening of the new H.G. Glyde Building, which housed well-equipped ceramics studios. A massive, gas-fired kiln was built as a course project under the direction of Luke Lindoe. For the first time, the Centre had adequate space for the teaching of a burgeoning art form.

Les Manning has provided dynamic leadership for the Ceramics Department since 1972.

By the 1980s, both ceramics and fibre were operating along similar lines: intensive, focussed summer courses at different levels, together with small, studio-oriented, unstructured Winter Programs. Visiting faculty like Elsa Sreenivasam, Walter Ostrum, and Franklin Heisler supplemented the work of permanent faculty – Rousseau-Vermette and Birstins in fibre, and Manning and Faye Munroe in ceramics.

The leadership of Les Manning and Mariette Rousseau-Vermette has been a major factor in the evolution of fibre and clay as artistic media in Canada. They would be the first to admit that it was only possible because of the tradition of excellence that had been developed over decades by those who had gone before. It is an exciting and turbulent period for these traditional "crafts," and the story is by no means complete.

Perhaps the changes have been best described by the words of two Fibre Interchange participants, Jack Lenor Larson and Mildred Constantine, in the introduction to their comprehensive book, *The Art Fabric: Mainstream*: "The distinction between the crafts maker and the true artist is precisely that the former knows what he can do and the latter pursues the unknown."

One of the illustrious teachers of the summer programs has been Ruth Duckworth of Chicago.

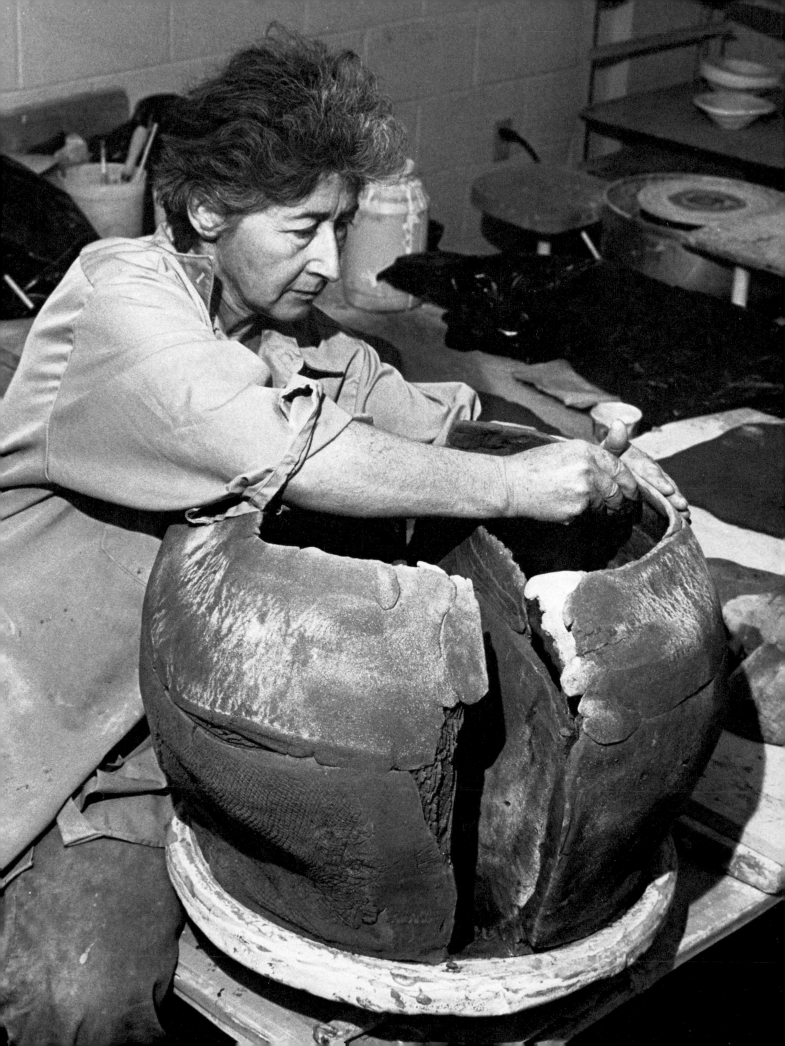

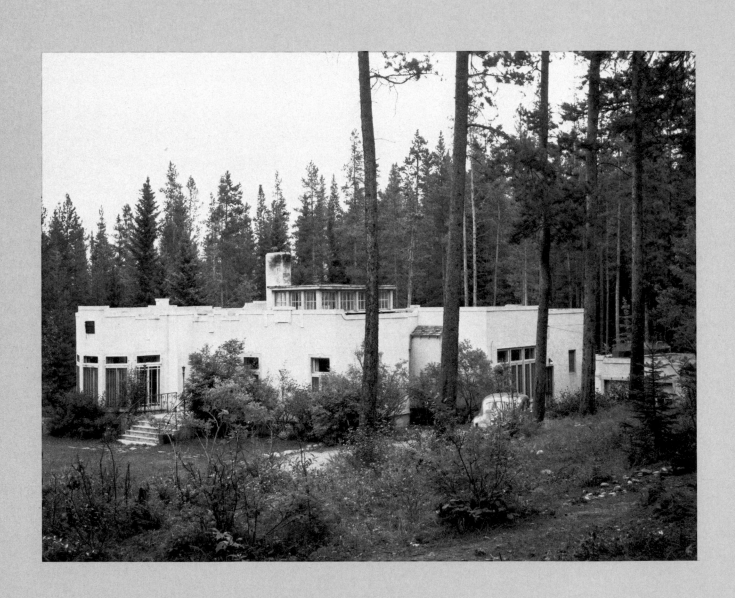

14

Du Courage, En Avant!

In the Banff School calendar of 1941, there appears the photograph of a fatherly-looking scholar named Albert L. Cru. Cru was a professor of modern languages at Columbia University in New York, and he had been persuaded to come to Banff to head the newly formed Oral French Program.

In the 1970s, such a course would not have seemed unusual, given the plethora of bilingualism programs sponsored by the federal government. But in 1941 in Alberta, where many schools did not even offer French, the initiation of a program in spoken French was a bold venture indeed.

Two years earlier, Donald Cameron had been approached by a delegation from the Calgary Association of French Teachers "to see if a course in Oral French . . . could not be included as part of the School Program." Catherine Barclay, an educator from Calgary who was passionately devoted to the goal of teaching French as *une langue vivante*, was one of the group. Another was Mary Clark, who had studied French at Columbia with Albert Cru.

Cathy Barclay's enthusiastic promotion of any idea was hard to refuse. She had been one of the first students in the Banff Drama Department, had taught drama, and had started a little-theatre group in East Calgary. She was a founder of the Canadian Youth Hostel Association, and devoted years of active service to various civic affairs in her native city. She believed strongly that there was no limit to the good that could be accomplished if people were not concerned with who received the credit. Her favourite phrase was *"Du courage, en avant!"* (Have courage, forward!)

Faced with such determination, Donald Cameron had little option but to acquiesce. Sensing a potentially strong addition to the Summer School Pro-

gram, and personally committed to the idea of Canada as a bilingual country, Cameron agreed to the organization of an experimental program in the summer of 1940, with Cathy Barclay as one of the teachers. The success of that trial run led to the decision to incorporate Oral French as a regular summer course, and to the recommendation that Dr. Cru be hired to lead the program. He brought with him Madame Yvonne Poirier from the Lincoln School in New York, and, in 1941, commenced a long tradition of French-language instruction in the unlikely surroundings of Alberta's Rocky Mountains.

Cru was an instant success. Cameron described him as an "unusually able" teacher, and the program flourished. He remained in charge of the course until 1949. Cru believed in what he called the "direct method" of teaching French, which today would probably be known as "immersion." French was the exclusive language of the classroom, and the students were housed in two chalets on St. Julien Road where French was spoken at all times. Later, when the Banff School had its own facilities, the students were assigned to their own French-speaking tables in the dining room and a French-speaking matron reigned in the residence. They did their best to create a totally French-speaking environment.

The establishment of the program was a particularly far-sighted move. Of course, it had practical, economic benefits in that it brought more students to Banff, but it was Cameron's commitment to the concept of a bilingual country that led to his saying yes at the critical moment, and it was one of his proudest accomplishments. Furthermore, Cameron did not shy away from a difficult issue that arose in connection with the program. He wrote, "For years the teachers of French in Alberta schools had been emphasizing their desire to have teachers from Paris

Holiday House, home of French programs at Banff for many years.

101

Break between French classes, on the steps at Corbett Hall, 1976. Instructor Magdy Badir in the checked coat (centre) is chatting with Philippe Laroch, program head (right, top). Danielle Laroch is seated lower right, Reginald Bigras lower left.

Dressed in shorts and running shoes and without warm clothes to face the wintry temperatures, they were in very low spirits indeed. We telephoned back to Banff and pressed into service toboggans, winter clothes, and anything else we could think of. For three or four days, while the snow remained, the students lived a winter existence in the middle of summer. In spite of the bad beginning, it was one of the most successful summer sessions ever, partly because we sent musicians and other performers up to Sunshine to entertain, and partly because the students rallied together in the face of adversity.

The following summer, the students were all gathered in the main dining room at Sunshine to hear an orientation lecture from the Park Warden. After a rather extensive treatise on the sensitivity of the alpine meadows and the problems that might be encountered in hiking in the area, he opened the session to questions. One student asked what one should do if one encountered a bear on the trail. As the Warden hesitated, a voice from the back of the hall piped up, "Ask the bear: *'Parlez-vous français?'*"

The French Department always included a few eager volleyball players, and an on-going competition with the Writing Department was a highlight of the summer for both groups. What they lacked in athletic skill was compensated for by their enthusiasm and good-natured ribbing.

Students of the Summer French Programs during those years will not forget "La Grande Soiree Française," which wound up each summer session. The evening usually concluded with a somewhat wild and woolly dramatic production, *en français*, featuring faculty member Reginald Bigras in the leading role. Bigras was a puckish, extroverted imp who had considerable dramatic experience; his version of "Little Red Riding Hood" was a masterpiece in any language.

In 1971, I went to Ottawa to visit John Carson, then Chairman of the Public Service Commission. I talked to him about the growing demand for French-language training and described the Banff experience. When I offered the Banff facilities to the federal government for language-training purposes, Carson leaped at the idea and encouraged me to take on additional staff.

In 1972 the Larochs resigned their positions at the University in Edmonton and moved to Banff to set up the first year-round French Language Training Centre. They also continued their regular summer school duties. The Larochs made an interesting addition to the Banff community. Phillipe, slim, nervous, and introverted, was complemented by Danielle, who was outgoing and vivacious. They were strongly committed to spreading French language and culture, and they launched the Banff *Alliance Française*, as well as sponsoring weekly French-speaking coffee parties, a tradition that continues today. The Larochs brought in two other full-time faculty members, Bigras and Peter Greene.

Arrangements were made with the Public Service Commission whereby senior public servants would be sent to Banff for three three-week periods in successive years. At the end of the three years, the participants would be functionally bilingual. The first party of federal civil servants duly arrived on the scene and the program was under way.

The results were excellent. The French faculty threw themselves enthusiastically into the job, working long hours to provide a French ambience in Banff. For several years, the program expanded according to plan. Then, mysteriously, the flow of civil servants slowed to a trickle.

Seeking answers, I made enquiries and discovered that the Public Service Commission was establishing its own school in Edmonton, and was diverting senior civil servants from Banff, ignoring our excellent record. Despite intensive discussions with Ottawa over the next two years, I was unable to

For several summers in the 1970s, French programs were held at Sunshine Village ski resort. Vanina Katz leads a discussion, 1971.

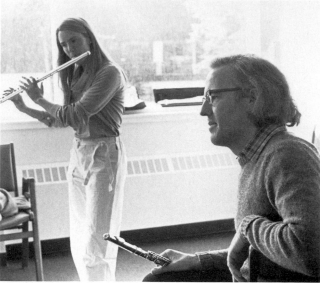

The heart and soul of Banff's Music Programs. Tom and Isobel Rolston and their daughter Shauna – the new "Rolston Trio."

Noted Canadian flautist Robert Aitken is a regular instructor.

"The Brass" perform. Banff's Brass Program took off when these five musicians arrived as faculty. (l. to r.): Fred Mills, Graeme Page, Charles Daellenbach, Eugene Watts, and Ronald Romm, collectively known as The Canadian Brass.

From the base of string quartets, the Chamber Music Program expanded, with faculty such as the duo Franco Gulli and Enrica Cavallo, Menahem Pressler of the Beaux Arts Trio, and noted cellists Janos Starker and Tsuyoshi Tsutsumi.

A significant turning point came in 1973 when the decision was made to audition students for positions in the Music Program. Until that point, all applications had been handled on a "first-come, first-served" basis. The result had been a very uneven and unpredictable class, and greater selectivity was clearly desirable. When the audition system was proposed, the Banff School was desperately short of funds. Faculty would have to travel to audition centres across the country, and the anticipated expense was considerable. However, it was obvious that it was necessary if the program was to improve. Those first audition years were a little shaky, but we learned from our mistakes, and it is now a very smooth operation indeed. Hundreds of young musicians are auditioned each February for the positions open in both Summer and Winter programs.

Beginning in 1973, the Orchestral Program was redesigned. Students came specifically for experience and coaching in the forty-five piece Canadian Chamber Orchestra. Successful applicants were on full scholarship, which included room and board. Competition was intense, and the auditions included separate screenings for the orchestra as well as for the individual instrumental and chamber-music programs. Over the years since its founding, the C.C.O. has grown and developed under the leadership of such conductors as Victor Feldbrill, Mario Bernardi, Sidney Harth, Lukas Foss, Klaus Tennstedt, and George Tintner.

Rolston's plan for expansion of the Music Department also included the development of programs in brass and woodwinds, as well as shorter courses in percussion and classical guitar. The Brass Program grew from a modest workshop that had been headed by Steven Pettes in 1966. In 1975, the effervescent Canadian Brass took over instruction, and the program took off, spawning brass concerts and impromptu recitals all over town. The new Woodwinds Program was headed for several years by flautist Harry Houdeshel from Indiana University; faculty included clarinetists Wes Foster, Robert Marcellus, Gervase de Peyer, James Campbell, Richard Waller, and Ron de Kant; oboists Frank Morphy, Perry Bauman, and Simon Trubashnik; flautists Robert Aitken, Jeanne Baxtresser, and Julius Baker; bassoonists Sid Rosenberg, David Carroll, and Sol Schoenbach; and horn players Fred Rizner, Gloria Johnson, David Hoyt, and Barry Tuckwell. George Zukerman, a bassoonist and impresario from Vancouver, came for several years and added many imaginative elements to the program.

A chance meeting in Toronto led to the addition of a Jazz Program in Banff. I was being interviewed on a television talk show in 1972 with Canadian jazz greats Oscar Peterson and Phil Nimmons. In conversation after the show, I offered them the opportunity to revive the jazz school they had once operated in Toronto, this time in Banff. They accepted, and both came the next summer, along with Nimmons' rhythm section: pianist Garry Williamson, drummer Stan Perry, and bassist Dave Field. Peterson would jam in the evenings on an old upright piano in the student pub, and the crowd would spill over onto the lawns outside, affording students a unique musical experience.

Later years saw the addition of singer-trombonist Big Miller, who had played with Ellington and Basie, guitarists Gene Bertoncini and Ed Bickert, flautist Paul Horn, saxophonists Eddie Daniels and Pat La Barbera, and trombonists Rob McConnell and Frank Rosolino. More recently, Karl Berger, Ken Wheeler, Dave Holland, Ed Blackwell, and Lee Konitz have been among the welcomed faculty members.

One of the enduring memories of that period was the nightly "Blue Room" jazz evenings held in a smoky cabaret atmosphere at which jazz faculty and student groups would play, often together. A regular in the audience for several years was the famous violist William Primrose, a devoted jazz buff. One opera student, Calla Krause, joined Big

Banff's first Jazz Program started in 1974. Oscar Peterson (l.) and Phil Nimmons (r.) headed the program that first year.

Imo von Neudegg, Vice-President in charge of Operations, discusses a point with Conference Manager, Catherine Hardie.

service" style of operation, where food was delivered on carts to the end of a long table for twelve, then passed from hand to hand in large serving dishes as diners helped themselves. Woe betide anyone who was late; the food, if any was left, was cold and well picked over!

It was an inexpensive system and it did encourage people to meet each other, but rigidity of meal hours and lack of choice were severe handicaps. Consequently, in the mid-1970s, the Centre converted to cafeteria-style service; table service remained available to certain groups. Under the guidance of managers Peter Cutting and Merv Seow, and head chef Jacques Beleyme, the variety and quality of meals improved immeasurably.

The expansion of the School's fine-arts activities through the winter, which started in 1972 and picked up speed in 1979, meant a reduction had to be made in the amount of space committed to conferences. Even in the mid-seventies, hundreds of groups were using the facilities each year, and it was getting difficult to book space on the Banff campus

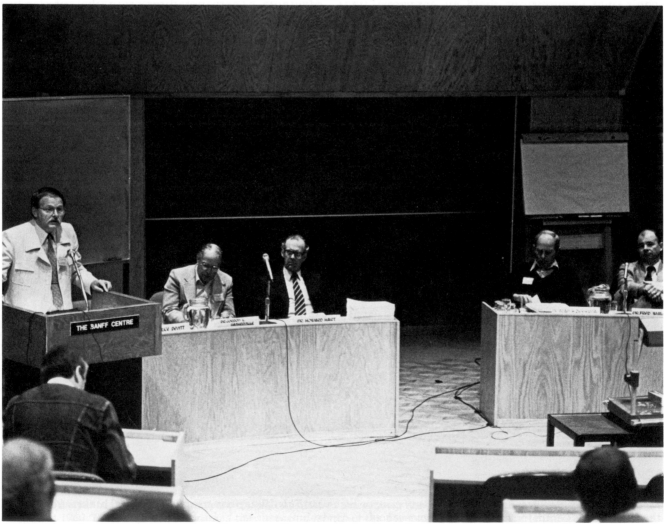

A national conference on forestry discussed urgent policy issues facing the industry, 1981.

The Alberta Square Dance Institute has gathered dancers from across the country for a colourful week every spring since 1955.

due to its growing popularity as a conference centre. The groups were vocal in their praise of the unique balance of accommodation, food, and classroom space, not to mention the opportunity to enjoy a wide variety of artistic experiences in the Centre's theatres.

While the amount of space committed to conferences has been reduced to permit the growth of the Winter Programs, the Centre's commitment to this aspect of adult education remains. It has always been seen as a useful method of grassroots contact with the people of Alberta, and of Canada. The problem was always to keep it in balance. In 1970, that balance point had been passed, and conferences were dominating the other functions of the Centre. A conscious decision to cut back was taken at that time, but the commitment to continuing conference activity was reaffirmed.

Since that time, von Neudegg and his staff have been working miracles as they juggle the declining space available against a growing demand. Somehow, they have managed to maintain a very high level of conference activity, and few groups have had to look elsewhere for accommodation. This has been important to the Centre, for not only do the conferences bring many people to the campus who would otherwise never have the opportunity, but it provides the Centre with an important source of revenue that helps it maintain a relatively independent financial position and, through that, artistic autonomy and freedom to experiment. That high degree of self-reliance has always been important to the attainment of its educational goals, a point recognized early on by Donald Cameron and reinforced in the years since.

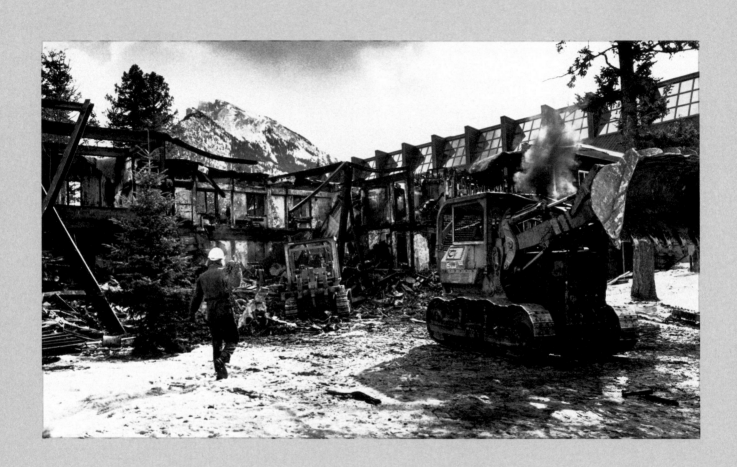

18

From the Ashes

Early on the morning of December 22, 1979, occupants of Crich Hall, which housed the Banff Centre's single-staff residence, faculty offices, and photography studios, were roused by smoke detectors squawking in the corridors. Hastily slipping into whatever clothes were at hand, they left everything else behind, and were evacuated to nearby Cameron Hall, where over the next twelve hours they watched Crich Hall – their home – burn to the ground. The fire effectively eliminated the teaching of photography at Banff until new facilities could be built.

The building was named after V.W. (Vic) Crich, who, more than any other person, had helped put Banff on the map in the field of photography.

Vic Crich was a tall, lean, soft-spoken, and reserved man. He lived in Toronto, where he taught photography at Ryerson Polytechnical Institute and operated a prospering photography business. He was a specialist in nature photography. Each summer for eighteen years, Crich came to Banff to head the six-week Summer Photography Program. He retired in 1972, and in 1976 the School, in his honour, called the building that housed the photographic studios Crich Hall. A Yousuf Karsh portrait of Crich hung in the anteroom of the photo studios.

In his memoirs, Donald Cameron described how it all began:

It had been our ambition from the founding of the School to develop a Photographic Division which ultimately would offer year-round courses in photography for the amateur; photography for science and industry; and colour photography. A small beginning was made in 1950 when Betty McCowan, a free-lance professional photo-

grapher, who was a native of Edmonton but who was working in Hollywood, put on a two-week course in photography for the amateur. The response was not as good as expected but at least we made a beginning.

Betty McCowan came for two more years, and Malak Karsh, a brilliant portrait photographer and brother of Yousuf Karsh, came to teach in her place in 1953.

Vic Crich picks up the story from there:

I had two widows in my class in Toronto, and they had been out to Banff the summer before under Malak, who was a far better photographer than I ever was. But, when they came home they wrote Dr. Cameron a letter saying how disappointed they were that they had just gone out and taken each other's portraits, and saying that if you want a really good teacher, get Vic Crich. I immediately got a telegram from him, 'How much do you want? Come on out.'

Crich came, and thus began a long and productive relationship with Donald Cameron and his School.

When he arrived in Banff, Crich quickly saw that the facilities were minimal. He decided that students would have to do most of their work in the field, except for processing of their film. As he had a strong leaning towards nature photography, this didn't bother him at all.

His students represented a mix of skills and interests. Some of his students from Ryerson came out with him. Others were rank beginners. Still others wanted exposure to the environment. One even came from California on the recommendation of Crich's former Toronto tailor, who had moved out to the west coast.

Crich found the arts faculty a small and friendly group. He particularly hit it off with pianist Boris

The remains of Crich Hall (Chalet Four) being removed after the devastating fire of December, 1979. Fortunately the new Glyde Hall to which it was attached was saved.

Vic Crich with his students on one of their many field trips to Johnston Canyon.

Roubakine, who loved nature and photography. Crich frequently asked Roubakine to judge the photography exhibition at the end of the year.

In the summer of 1961, Crich was provided with an assistant, Robert Alexander, a native of Calgary, who at that time was teaching at the Brooks Institute of Photography in Santa Barbara, California. His job was to set up the technical facilities and hire any special faculty required. Alexander came from California to Banff for two years, then was invited to become Head of the Photography Division at the Northern Alberta Institute of Technology in Edmonton, and moved back to Alberta. Bob recalled his early days in Banff:

> In 1961 we were operating from a tiny photographic lab that was tied into the ceramic lab, where the Spectrum [the campus store] is now. The two were totally incompatible because, of course, the clay and the dust from the ceramics seeped throughout the photo lab! And the ceramic people would complain about the chemistry smell from the photo department. The Solarium was then the dance studio; it was right overhead. That year, they were doing *Swan Lake* and we literally had to time our enlargements between jumps. I think I've hated *Swan Lake* ever since.

Crammed into the same space was a tiny little room that the photographers used as a classroom. With about twenty students and only two enlargers, the class had to work in shifts. But despite the rudimentary facilities, Alexander said that "those of us who started at that period ended up being proud of what we could do with very little, and I think that was transmitted to the students."

The association of Alexander and Crich continued for eleven productive years. Under their leadership, the program developed and expanded year by year. In the 1960s the emphasis started to change. There were increasing demands in terms of the technical side of photography and the little studio under the Solarium was becoming inadequate.

At the Northern Alberta Institute of Technology in Edmonton, Alexander had new facilities and marvellous equipment. He made a deal with the Senator: if more adequate space could be provided, Bob would bring equipment to Banff from his Edmonton lab in the summers. So in 1965 the department moved into Chalet Four, later to become Crich Hall. And each summer, a big truck would roll up to the N.A.I.T. campus and load equipment destined for the Banff Summer School.

"I think because of that the nature of the course began to shift," said Alexander. "It became less pictorial-oriented and more lab-oriented. We had to find a balance for these directions, and that was when we began two-week programs in June, more technical in nature. We also moved into colour photography about that time."

Despite the improved facilities, one major problem was to remain: the water. Photographic processing required good water, and Banff's was anything but perfect. There were always impurities, and each spring and early summer the water literally ran brown with the runoff. Bob Alexander remembers going to Don Becker to ask for eight or ten garbage pails in which to hold the water so the impurities could settle. He got them, but the problem of water was to plague the Photography Program for many years thereafter.

In 1971, when Ken Madsen and I were looking for someone to spearhead the first winter pilot project in the arts, we drove up to Edmonton to talk to Bob Alexander. Alexander was excited at the idea of starting his own school and agreed to come on the condition he could bring with him Ben West, his Technical Assistant from N.A.I.T. Together, Alexander and West mapped out a winter curriculum and developed a plan for upgrading facilities. The resulting program was to be the foundation of what evolved as the Banff Centre's Winter Cycle. Bob Alexander recalled those modest beginnings:

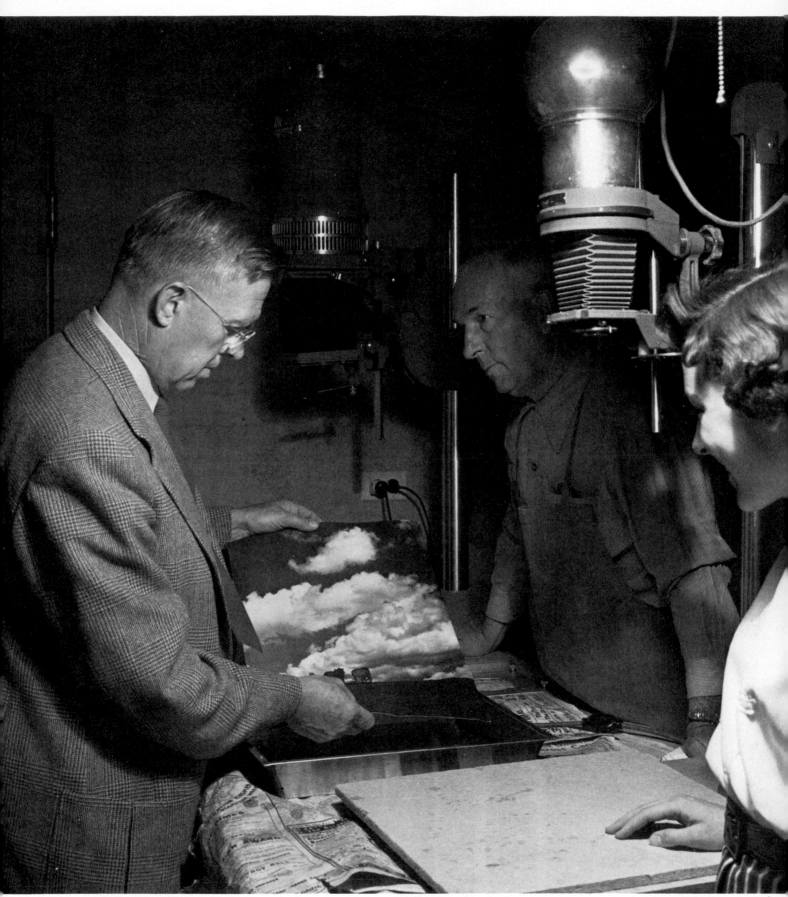

Vic Crich (l.) in the darkroom. Laboratory facilities were not very sophisticated in the forties.

Bob Alexander developed the year-round program in Visual Communications. He later became Manager of Visual Arts Programs.

(Left) Wilderness photography with teacher and guide Bruno Engler was a favourite in the summer of 1971.

I remember David Leighton saying to me, "I want you to put your dreams on paper; make a proposal to me and let's see what can follow from that." So I went back to N.A.I.T. and developed an idea. At that time, because of the colour course earlier and because of some of the requests that I had from industry in particular, I suggested that one of the things that we could do was offer a whole series of specialized short courses in the winter time – courses that would be given to printers or medical photographers. While we did quite a lot of that for a time, we found that in dealing with a specialty, each course required different sets of equipment and it became very unwieldy to try to meet the needs.

They gave a course in Photographic Map-making and received a good response, but weeks were spent in advance trying to find three-dimensional map-readers and other very technical equipment. The result was that, at about the same time, Alexander proposed that the School introduce a year-round training program that would put its emphasis on the mature student who did not necessarily have a great deal of photographic background, but who had some worthwhile experience to share.

We felt that there was a great proliferation at that time of training programs in photography, mostly for commercial photography, which was what I was involved in at N.A.I.T. But I thought there was a need for a training program, which we called "Visual Communication," based on the philosophy that the great strength of photography lay in its ability to clarify something. What I found in training young people, was that none of them had really lived enough to have any particular experience or any particular skill that would support the photography. . . . Where I felt that there was great opportunity was with the engineer, or the biologist, or the physicist, or the architect, or the artist, who needed photography to support or clarify his work.

The students came, largely through word of mouth, from a wide variety of backgrounds. Chris Czartoryski came from an engineering background; Randy Bradley had a B.A.; Alison Rossiter and Barbara Spohr were interested in art; Fred Solylo had several years of photography already under his belt. It was tough in those early years. They were the only full-time winter students on campus, and they felt the isolation and lack of proper facilities. They knew they were guinea pigs, and Alexander told them frankly he didn't have a firm idea where the program would lead. The fact that a high proportion of graduates has been successful in the field is a matter of great pride to him.

The program was handled entirely by Alexander and Ben West the first year. Then, as it grew, more faculty were required. Robert Pfeiff, a bearded and outspoken former U.S. Navy test pilot who had lost one leg in an aircraft-carrier accident, came on as a Technical Specialist. Pfeiff had been on the faculty of the Rochester Institute of Technology for several years prior to joining the Banff faculty.

During that period, the Centre also made an attempt to enter the field of film-making, an area of increasing interest in the visual arts. For several summers, former Czech film-maker Miroslav Malik, from Concordia University in Quebec, headed a summer program, but it, too, was plagued with problems of inadequate equipment and facilities. Enrolments were not large, and the decision was made to withdraw until a more solid base was in place.

By coincidence, at just this time, a prominent figure in the film world moved to Banff and took up residence. He was Milton Fruchtman, two-time Peabody award winner for his television programs on the Sistine Chapel ceiling and on the Dance Theatre of Harlem. Fruchtman's daughter, a violinist, had participated in the Chamber Music Program in Banff, and her enthusiasm prompted her parents to move from New York to settle in Banff.

Fruchtman participated briefly in the early ventures in film-making, and when the Centre did re-enter the film field in the 1980s, he joined the staff full-time, planned the program, and took charge of the teaching himself.

Meanwhile, seeking a change from teaching, Bob Alexander had moved over to become Manager in charge of all Visual Arts at the Centre. Seeking additional depth in photography, in 1977 Alexander hired Hubert Hohn, a well-known photographic exhibitor, writer, and graphic-arts specialist. The decision was made to take a major shift away from the technical base on which the program had started, and Hohn became Department Head in 1979. The photographic studios were redesigned and new facilities built based on a studio style more in tune with the other Winter Cycle programs of painting, ceramics, and fibre.

The new studios were barely completed when fire struck Crich Hall, and the entire photographic teaching facility went up in flames. Hohn, particularly, suffered a heavy loss of files and teaching materials. Many students lost all their work.

in Macdonald's composition *Tam ti-delam*, which became a standard in the repertoire of Les Grand Ballets Canadiens.

During his student days at McGill, Macdonald had been one of the vital forces behind a famous and funny university revue called *My Fur Lady*, a spoof on things Canadian that enjoyed considerable vogue at that time. One of his collaborators on that show had been writer Bill Solly. When Macdonald took over Musical Theatre at Banff, he engaged Solly, then a free-lance writer in England, to write a number of original musicals for Banff, including *Vamp Till Ready* (1964), *Made in the Mountain* (1965), and *Come North, Come Home* (1966). The last was designed to be edited and redone as the

feature production in 1967, the Centennial year, but Solly declined to rewrite the script and did not return to Banff. Macdonald also left after 1966, and was succeeded as Head of the Department by George L. Palmer, a former Banff student then working in theatre in Calgary. Palmer remained for three years. Irene Prothroe had been Head of the Drama Department since 1965, and when Palmer left in 1970, she assumed responsibility for Musical Theatre in addition to her Drama Department responsibilities.

She put together a team that consisted of herself, Berthold Carriere, Jack Robertson, Keith Simpson, and Diana Belshaw. This talented group produced some of Banff's most memorable musicals: *The Boy*

Come North, Come Home was an original musical written by Bill Solly in preparation for Canada's Centennial. In its first and only presentation in 1966 are (l. to r.): Janice Kruk, Dena Brown, Jennifer Ciurluini, Gerry Wilkie and Adele Armstrong.

134

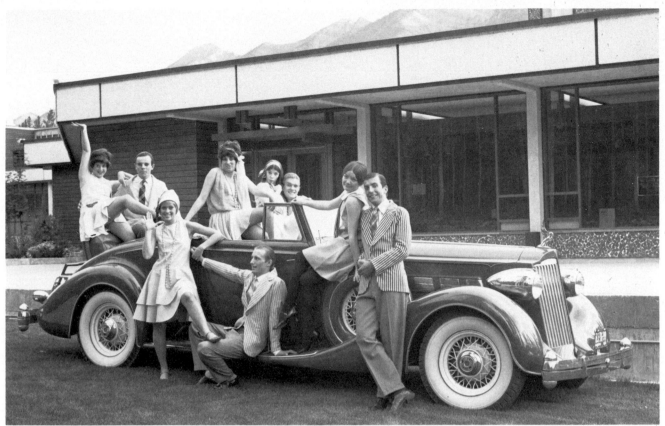

The Boy Friend *was the first of a series of highly successful musicals directed by Irene Prothroe. Lorna Luft is in the rumbleseat at back.*

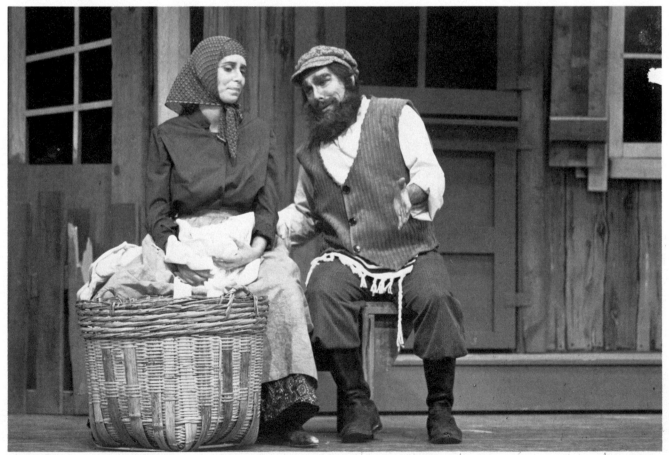

Alexander Gray and student Faye Cohen sing a duet from Fiddler on the Roof, *1974.*

135

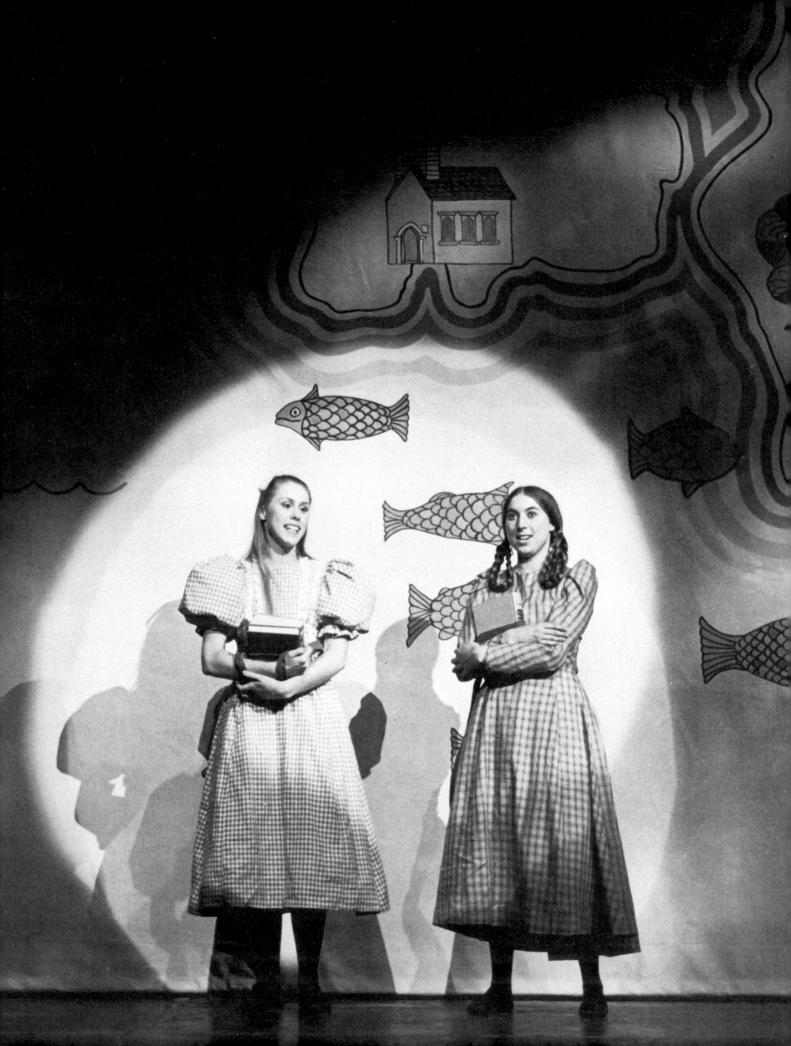

Friend (1970), *The Sound of Music* (1971), *Man of La Mancha* (1972), *Fiddler on the Roof* (1973), and *Anne of Green Gables* (1974). Lorna Luft, daughter of Judy Garland, showed she had inherited some of her mother's talent in a major role in *The Boy Friend*.

In Prothroe's 1974 production of *Anne of Green Gables*, she cast a perky young opera student from Red Deer in the role of Anne. Frances Dietz was made for the part, and later went on to study voice in California, where she suffered a serious stroke that left her partly paralyzed. Her career seemed over, but this spunky young lady fought back with a determination that inspired everyone who knew her. She eventually carried on with her studies, played character roles in productions around Alberta, and set up her own voice studio in Edmonton.

Irene Prothroe was a tough taskmaster; she knew what she was doing and the results showed it. A veteran of many summers at Banff, Irene had frequently been on the other side of arguments with the Senator. She never took those arguments too seriously and she knew how to make her point.

Prothroe recalls the years when all of the faculty at the entire school sat around three tables in the dining room:

> We had to go to every concert. *Had to.* We were counted and we had to sit in the front row for everything. So we all had to be dressed up.
>
> One year, I decided the Senator wasn't paying me enough money, so I was going to set up a tent in the campground to economize on housing. Jack Graham always camped and he helped find me a spot and set up my tent. The Senator was furious, but there wasn't anything he could do about it. And, as we had to be dressed up for the concerts, I brought a mink stole with me. So I used to hang the mink on the tent pole and when I went out to the concerts, I'd get all dressed up and put on my mink. I'm sure the people in the campground thought I did something else at night!

She got a raise the next year.

When Prothroe left to join the CBC in 1972, she turned over the Musical Theatre Program to Alexander Gray. Gray, in turn, imported as a Director and Acting Instructor Michael Bawtree, former Assistant Director at Stratford (Ontario) and a faculty member from Simon Fraser University. Gray also recruited well-known conductor and

Michael Bawtree, Head of the Musical Theatre summer programs since 1976 and now in charge of the new Music Theatre Winter Program.

musical arranger Howard Cable as Musical Director and Dodi Protero and James Beer as Vocal Coaches. In 1975, one of Gray's students, Wanda Cannon, almost completely untrained, won a secondary part in the production of *Carnival*. A statuesque blonde, Cannon blossomed into a star the following year as the shrew in *Kiss Me Kate*, and later performed leading roles in Charlottetown and Toronto. Jayne Lewis, who played the part of Fiona in Bawtree's production of *Brigadoon*, also achieved prominence on national stages. Ross Thompson, the leading man for both of these ladies, developed a fine acting style and a rich baritone voice which won him major roles in operatic productions across Canada.

Frances Dietz (r.) was Anne of Green Gables, in 1973. Her best friend was played by Myrna Sinkinson.

Roby Kidd was called on by the Alberta Government in 1969 to make a study of the future of the Banff School of Fine Arts.

Centre should be confirmed; there was some danger of this being submerged in the growth of conferences.

4. The place in the Centre of management training should be affirmed, especially in fields other than business. Consideration should also be given to the needs for continuing education among professional groups (teachers, for example), para-professional personnel and others.

5. The Centre should be "a home for experiment and innovation on all matters of public-affairs programming, as well as those matters that help people cope with the personal problems that face most members of the human family."

He recommended rewriting the Centre's lease with Parks Canada, a document that he found unduly restrictive on the Centre. He proposed that the University of Calgary be invited to assume the role and responsibility of a trustee for the Centre, "and if that did not work, the Centre might be given the responsibility of an independent institution."

As for programs, the Centre should continue to feature programs in the fine arts, "but with full recognition that the situation respecting the arts in Alberta is changing significantly and rapidly. The Centre can no longer serve all students of the arts or all purposes."

Finally, Kidd strongly recommended that standards be raised, not only in programs, but also in physical facilities and administration. Additional finances should be provided by the Alberta government to make this possible.

Meanwhile, the search committee for a new Director had been active. It had interviewed a large number of individuals, both from the Centre's staff and outside, and narrowed the list down to a number of names. Grant Carlyle, a member of that committee, recalls someone mentioning David Leighton. I was then a professor at the School of Business Administration at the University of Western Ontario.

The first contact was made in the fall of 1969 at the unlikely locale of the Seigniory Club in Montebello, Quebec. As Chairman of the Canadian Consumer Council, I was a featured speaker at the annual meeting of the National Dairy Council of Canada. Grant Carlyle, President of Union Dairies in Calgary, was a delegate. Following my address, he invited me to the bar. Over a glass of beer, we discussed the possibility of my coming to Banff. I was interested in a change, and arrangements were made for me to visit Calgary and Banff later in the year. Some weeks later, I flew to Calgary, met the selection committee, visited Banff, and met the incumbent staff. Later, Cameron flew from Ottawa to London, Ontario to meet my wife, Peggy, and me on our home ground. Apparently he, too, gave his approval to my appointment.

I was forty-two years old at that time and a westerner by birth, having spent the first eight years of my life in Calgary, where my father had been managing editor of the Calgary *Albertan*. I studied economics at Queen's University, where I met Peggy. She taught at a college in Boston to support us while I studied for my M.B.A. and then my doctorate at Harvard University. We returned to Canada in 1955, and I joined the then-small School of Business Administration in London, Ontario. My specialty was marketing, and I was privileged to be one of a small group of mostly Harvard-trained faculty who helped build Western's program into one with an international reputation.

It was during those years that business administration was gaining acceptance as a legitimate area of university study. That led to teaching invitations in many countries of the world. On two occasions we moved the entire family to Switzerland for a

(Above) University of Calgary special convocation held at Banff in 1969. Receiving honorary degrees were (front row) Ernesto Vinci, Catherine Whyte and Earle MacPhee. Behind them stand Campbell McLaurin, Chancellor, and A.W.R. Carrothers, President of the University of Calgary, and Donald Cameron. It was on this occasion that the retirement of Donald Cameron as Director of the Banff School of Fine Arts was announced.

Eric L. Harvie (r.) and David Leighton at the opening of the 1971 Banff Festival.

147

year. In the summers I directed a six-week program in Cambridge, England.

Those were exciting days in Canada. There was room to grow for anyone willing to take responsibility. I was appointed first Chairman of the Canadian Consumer Council in 1968, and was the first Canadian to be elected President of the American Marketing Association, for 1971-72. An amateur violinist, I was on the Board of the London Symphony Orchestra and played in the university orchestra.

Our five children were happily settled in their various schools. Peggy was active in community affairs and we enjoyed our home on the Thames River. I was at the top of my academic career. That was just the problem: we were too comfortable.

Teaching and research no longer held as much challenge for me as they once had. We saw in Banff an exciting institution with a great past and equally great future. It was a relatively small school where one could identify with the staff, faculty, and students. The new role was one that would require a team effort for Peggy and me, just as it had for Donald and Stella Cameron more than thirty years before.

In the winter of 1969, Peggy and I visited Banff before we made a definite decision to move. As we drove west from Calgary on the Trans-Canada Highway, the sky was overcast and the countryside was windswept and freezing cold. But as we came over the crest of Scott Lake hill, the sun came out, the sky cleared to a brilliant blue, and on the horizon, the mountains were shining. Our spirits rose. When we got to Banff and met the people at the Centre, we were both completely captivated.

In February 1970, I accepted the job as Donald Cameron's successor. We arrived just before Christmas and moved into the new Director's house that had been designed by architect Michael Evamy. We loved the house and since we are a gregarious family, we have had many enjoyable dinners, receptions, and musical evenings there.

Our five children were soon at home in Banff and on campus. In the 1971 production of *The Sound of Music*, the two youngest Leightons played the two youngest Von Trapps.

Change at the Centre took place slowly at first. I had to absorb something of the history and tradi-

(Right) Peggy and David Leighton.

Prime Minister Trudeau and his wife, Margaret, visited the Banff Centre in 1972 and attended the premiere of George Ryga's Sunrise on Sarah. *Dr. Leighton leads the way with Jennifer and Andrew Leighton.*

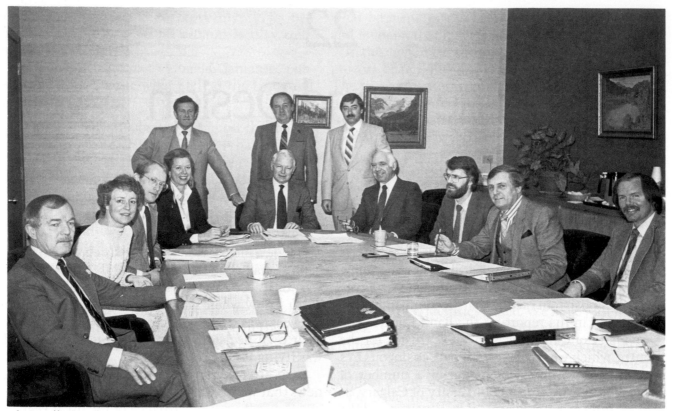

The Banff Centre's management team, 1982. Standing (l. to r.): John Chapman, Pat Judge, Gary Frey. Seated (l. to r.): Don Hodgkinson, Catherine Hardie, Peter Greene, Frances Jackson, David Leighton, Neil Armstrong, Norbert Meier, Imo von Neudegg, Garth Henderson. Absent: John Tewnion.

province, by 1970 there had been an explosion of arts activity in universities, community colleges, technical institutes, YMCAs, and so on. Most centres in the province now had easy access to institutions where residents could obtain early training, inexpensively and conveniently, in almost any art form. Banff, which had been set up to foster the spread of the arts, was in danger of becoming a victim of its own success. At the same time, the Centre had grown so fast and had so many students that there was a real danger of getting lost in numbers. The growth of other institutions posed the danger of leaving Banff to draw those who wanted a holiday in the mountains and for whom cost was no object, instead of serious artists committed to making their art their profession. In some cases, class sizes were too large and quality had suffered. The program was uneven and lacked clear direction.

A few decisions were made quickly. The overall size of the Centre was to be frozen and efforts would be made to reduce the numbers of people and programs that were currently being handled. One of the good things about the Centre was that for a long time there had been a close personal relation between students and faculty and staff. In recent years, there was danger of losing it in the rush to grow. Quality education is best achieved in per-

sonal, human terms – that is, in small groups.

The management training element of the Centre was to be retained and its standards upgraded. Pre-eminence of the arts was to be emphasized. The School of Fine Arts, the *raison d'être* for the Centre and once its only activity, had shrunk to about one-third of the Centre's capacity; conferences were accounting for more than 50 per cent. The Centre had gone from being an arts school with an incremental conference business to being a conference centre with an arts school attached. Complaints had been voiced by the Calgary Convention Bureau and other commercial establishments that the Centre was competing for convention business that would normally go to tax-paying commercial hotels. Conferences had become big business. A decision was made to reverse the process of recent years – to increase the fine arts component and to reduce the emphasis on conference activity. There was clearly a role for the Centre in hosting education and public-service conferences, but the need to generate more funds had pushed that role beyond the desirable proportion.

Arising from the decision to re-emphasize the arts was another basic decision, perhaps the most important: that fine arts would be extended through the year, that enrolments in the summer session

would be gradually reduced, class sizes cut, faculty increased, and emphasis placed on intermediate and advanced arts training rather than elementary- or beginner-level work, which in recent years had been taken over by local communities anyway.

To do this would require money – for scholarships, for more faculty, and for more and better facilities. A number of the buildings on the campus had been built in an earlier era and were in urgent need of upgrading and maintenance. The need for additional funds meant the province would have to play a more active role than it had in the past in supporting the Banff School, especially if the conference activity was to be reduced.

If we were to accomplish these goals, we had to do three things:

1. We had to have a master plan that reasserted our primary role as an educational institution. That plan, and the financing needed to carry it out, would have to be sold to the provincial government.
2. We needed a new lease from Parks Canada that recognized this shift in role, that outlined the kind of campus required and gave us the flexibility to develop along these lines.
3. We would eventually need autonomy from the University of Calgary, that is, separate legal status. I was quickly becoming convinced that, while the university link was in some ways an asset, the greater danger was that we would get swallowed up in the university structure. This would be disastrous for Banff and everything we had worked for in the past.

The master plan embodying these directions was completed in January 1971 and won the Banff Council's approval. With this encouragement, we set out to implement the plan.

A number of steps were taken throughout the next few years. The Summer Arts School was extended from six weeks to twelve. The Summer Festival was revamped and expanded. Plans were initiated for experimental, pilot winter projects in the visual arts, beginning with photography and soon to embrace drawing and painting, ceramics, and weaving. These were to be the testing pattern for an overall Winter Arts Program to follow. Individual faculties were put under the appraisal microscope, advisory committees were brought in, and steps taken to upgrade faculty and revise the curriculum. By 1972, a number of programs had undergone this process. Winter courses were launched, scholarship funds were dramatically increased, and arrangements were negotiated with the Public Service Commission in Ottawa to hold a number of their French-language and management-training programs at the Banff Centre.

New programs were started in two fields. One was arts management, where seed money from the Donner Canadian Foundation provided the financial foundation. The other was environmental management, where a grant from the Devonian Foundation of Calgary provided support for the first three years of an experimental series of management courses aimed at business people, public servants, and private interest groups concerned with maintaining a balanced approach to preservation of the environment.

The Board of Governors, 1982
Seated (l. to r.): Phillippe de Gaspé Beaubien, Ralph Scurfield, Claude LeBlanc, Harley Hotchkiss, Gordon Lennard, George Yeates, Grant Carlyle (Governor Emeritus), James Fleck, Susanne Palmer, Carolyn Tavender (Chairman). Standing: John Poole, Jack Krecsy, David Leighton.

153

Lengthy negotiations were commenced with Parks Canada on a revised lease and the long-range campus development plans that would form its base. These negotiations culminated in 1979 with a new lease that released the Centre from some of the restrictions in the earlier document.

The process of convincing the provincial government to back the Centre's plan began in 1971. In the fall of that year, the long reign of Social Credit ended in an electoral sweep by Peter Lougheed's Conservative Party. I had known Lougheed at Harvard, where we both had been students in the early fifties. One of the first moves of the new Premier was to appoint as Minister of Culture a stocky, cultural evangelist named Horst Schmid, who believed passionately in building a strong artistic community. A new day was dawning for the arts in Alberta, and the new government was determined to shed the province's image as a cultural backwater. The Banff Centre's ambitious plans fit right in with the goals.

The process was helped in 1973 when, to the shock of the rest of the world, the formerly passive Organization of Petroleum Exporting Countries suddenly raised the price of oil dramatically. Alberta, as producer of eighty per cent of Canada's oil, suddenly found itself the country's wealthiest province. Money was available to help advance the government's goals of upgrading the cultural life of the province.

Banff's master plan was first discussed with the government in 1971. It won endorsement from the Commission on Educational Planning, headed by Dr. Walter Worth. It was also backed by later studies of the arts in the province.

One of the key steps to the School's progress was winning the approval of the Minister of Advanced Education, Bert Hohol, as well as the Premier. During the winter of 1976, Premier Lougheed was on vacation in Banff and spent a good part of an afternoon in my office. We discussed the future of the School at length and I told him our plans. He agreed to have them brought before the Alberta Cabinet, pledged his personal support, and asked my commitment to stay on and see them through.

In the spring of 1977, Ted Mills, Neil Armstrong, and I went to Edmonton and made a presentation to the provincial Cabinet. We outlined the direction we wanted to go and how much we thought it would cost. The Cabinet approved the broad outline of the program. The Banff Centre Act, giving us autonomous status within the post-secondary system, was proclaimed on April 1, 1978. It gave us our own Board of Governors; we became, to all intents and purposes, a fifth university in Alberta.

Since that time, the affairs of the Centre have been legally vested in the Board. Its members have been a distinguished group of Canadians, drawn from all across the country. Its first Chairman was Grant Carlyle; he was succeeded in 1981 by Carolyn Tavender of Calgary. The strength and independence of the Board has been an important factor in the Centre's development.

The process of fleshing out the master plan had been thoroughly studied and discussed during the winter of 1977, when the School invited advisory committees in the various arts disciplines to help develop plans for each of the disciplines: visual arts, music, theatre, dance, and electronic media. This process culminated in the publication of a prospectus entitled *A Turning Point*, which mapped out the intentions of the Centre in its Winter Cycle activities. Most of the programs proposed in that document are now in place. The maximum number of students in winter programs will be between 250 and 300, in a wide range of artistic disciplines.

The master plan also called for major changes to the campus. When I became Director, my first decision had been to freeze growth, to put the building of new structures on hold, and to maintain and upgrade what was there while long-range plans were being developed. A program was developed for renovation of the original three chalets, replacing small rooms and communal toilets with larger private rooms with baths.

I enlisted a soft-spoken Calgary architect, Michael Evamy, who had designed the Director's house, to help with future planning. Evamy's first big project was to design a new residence containing sixty rooms to complete a small quadrangle with the original three chalets. Dedicated in 1973, the building was named Corbett Hall after the father of the School, Ned Corbett.

In 1976 a visual-arts facility, Glyde Hall, was built adjoining the photographic studios in Crich Hall. Glyde Hall provided much-needed facilities for sculpture, fibre arts, ceramics, and painting. It also provided the School's first art gallery, named after Walter Phillips, to serve as a focal point for the various visual-arts disciplines. Crich Hall had also been used as a staff residence, and when it was destroyed by fire on December 22, 1979, more than fifty staff members were without a place to live. ATCO trailers, normally used in remote sites, were

brought in as temporary staff housing until a new residence for single staff members was completed in July 1981.

The 1979-80 period was busy for construction on campus. John Tewnion, the bouncy, Scottish-born Head of Building and Grounds, had three major projects under way at the same time: the new staff residence, an addition to the Lloyd Hall residence, and the Max Bell Building, financed by a major gift from the Max Bell Foundation of Calgary.

At Christmas 1980, I was invited to the home of Mr. and Mrs. Robert Borden of Banff. Mr. Borden, a wealthy businessman, had been a generous supporter of scholarships at the School for a number of years. He told me that he wanted to give the School a million dollars towards a new building to be used as a social and athletic centre for the campus. After a lengthy design period, that building, supported by the Borden gift and an additional seven million dollars from the provincial government, is to be opened in 1983. It will house a swimming pool, gymnasium, racquetball courts, exercise rooms, and student lounge facilities. The immediate future will also see a replacement of the photographic facilities destroyed by fire, as well as increased staff housing.

By 1984, the pace of construction should begin to slow down. Although several big projects are in the works, the long-range plan for the campus projected an end to significant new projects by 1984-1985. After that, the plan is to stop vehicular traffic through the middle of the campus and create a central pedestrian mall. With parking and automobile traffic confined to the perimeter of the campus, the plan will be essentially complete.

In its fiftieth year, the Banff Centre presents a picture of glowing health. It boasts excellent people at every level and in all departments. Its facilities are first-class, and it is financially sound. Standards have risen, and with them our reputation internationally.

In many respects, the story of the Banff Centre reflects Canada's cultural development. As our nation has matured, so have the arts, and the Banff School has played an important part in that process. The future looks bright for the mountain School that began fifty years ago with the efforts of Ned Corbett and Elizabeth Haynes.

Now, a half-century later, I turn over the leadership to a new President, Paul Fleck. And the story continues.

The history of the Centre is, above all, the story of individuals, men and women with a common purpose: to create on a mountainside overlooking the Bow Valley in the Rocky Mountains a school to foster the flowering and maturing of the arts and management in Canada and around the world. These individuals comprise a brilliant parade of artists, builders, and dreamers who shared a vision and made it come true.

David Leighton bids farewell at a staff meeting held to introduce his successor, Dr. Paul Fleck (r.).

Cast of Characters

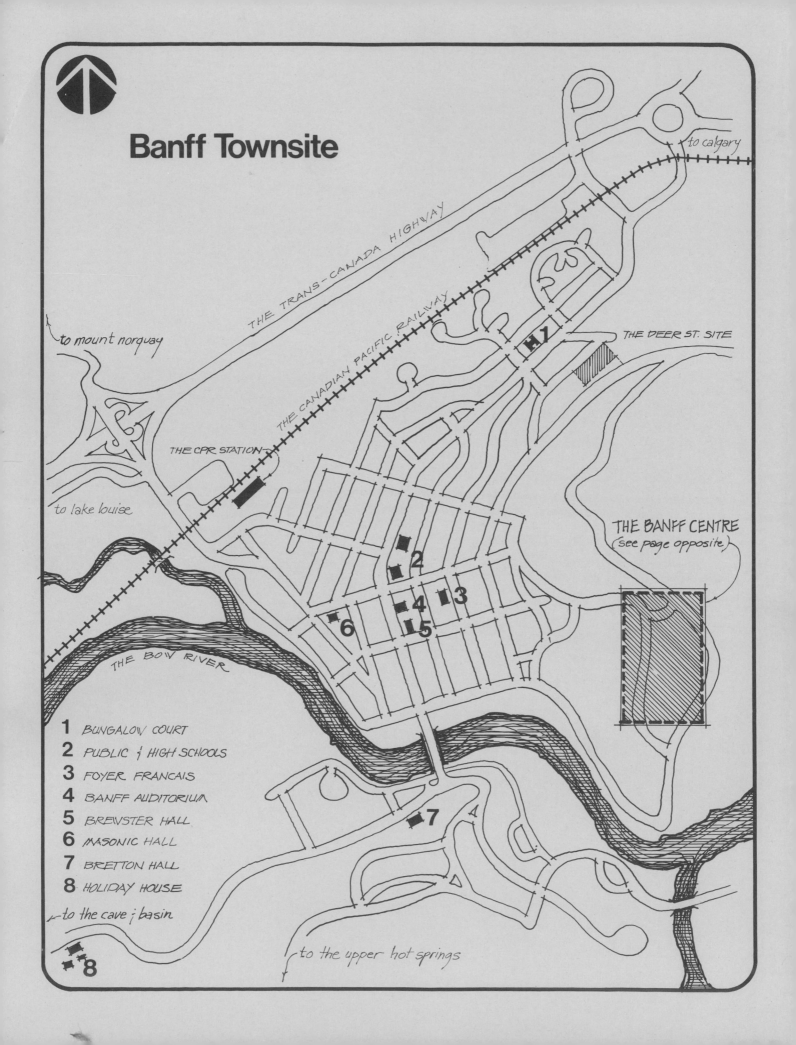

Banff Townsite

to calgary

THE DEER ST. SITE

to mount norquay

THE TRANS-CANADA HIGHWAY

THE CANADIAN PACIFIC RAILWAY

THE CPR STATION

to lake louise

THE BANFF CENTRE
(see page opposite)

THE BOW RIVER

1 BUNGALOW COURT
2 PUBLIC & HIGH SCHOOLS
3 FOYER FRANCAIS
4 BANFF AUDITORIUM
5 BREWSTER HALL
6 MASONIC HALL
7 BRETTON HALL
8 HOLIDAY HOUSE

to the cave & basin

to the upper hot springs